Anne-Karoline Distel
100 Birds of Ireland in Watercolour

© Anne-Karoline Distel 2018
All rights reserved.
100birdsofireland@gmail.com

For the Magpie

Preface

This collection of watercolours evolved out of a challenge to myself to paint an Irish bird every day from December 1st to 25th 2017. I had only become interested in birdwatching shortly before I started the challenge, so the variety was quite fascinating to me – especially with the water birds, being a city person.

A friend suggested that it should be made into a book. So I extended the challenge into the new year and ended up with a bit over 130 birds in total. What appears in the book is a selection of 100 of those Irish bird paintings, the ones I like best or considered important in such a collection.

The book is not entirely systematic but begins with the common garden birds - those one can see at the bird feeder; it continues with birds to be found in town and country, and ends with water birds.

Discovering the Irish names and comparing them to their counterparts in the other languages was a particular pleasure – I hope I found the correct names for all of them. There is no index, because the book is meant to be explored rather than being used as a guide.

I hope you enjoy this book as much as I enjoyed painting the birds and learning their names!

<div align="right">Kilkenny, July 2018</div>

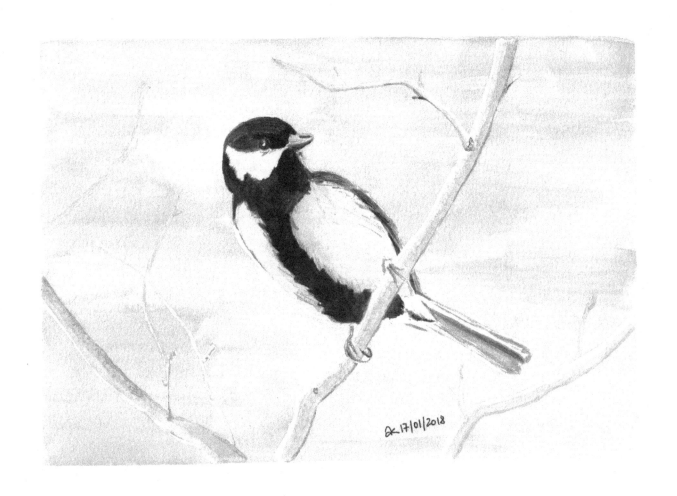

Parus major

Great tit ◆ Meantán mór ◆ Kohlmeise

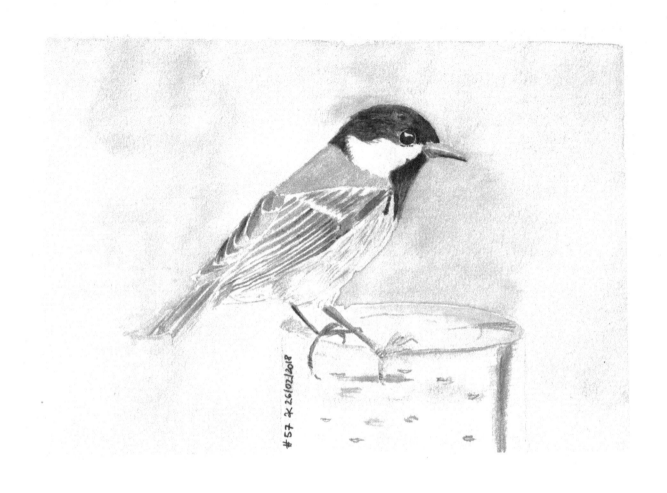

Parus ater

Coal tit ♦ Meantán dubh ♦ Tannenmeise

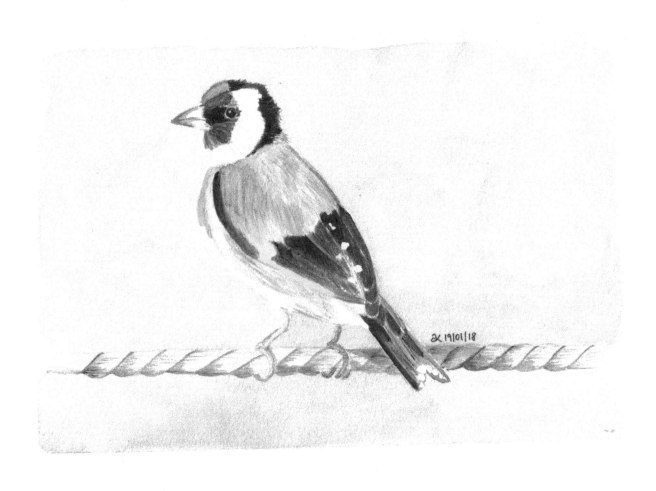

Carduelis carduelis

Goldfinch ♦ Lasair choille ♦ Stieglitz/ Distelfink

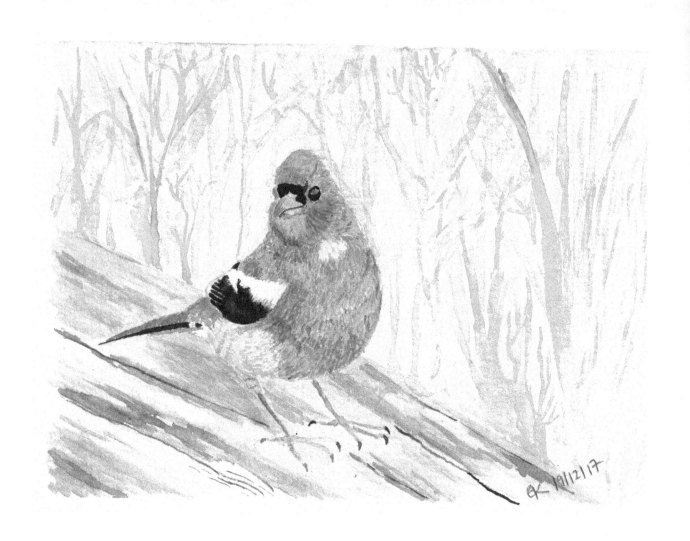

Fringilla coelebs

Chaffinch ◆ Rí Rua ◆ Buchfink

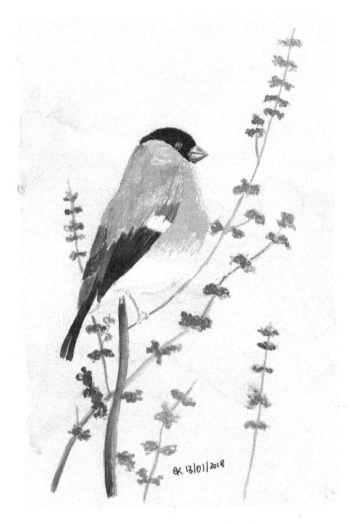

Pyrrhula pyrrhula

Bullfinch ♦ Corcrán coille ♦ Dompfaff/ Gimpel

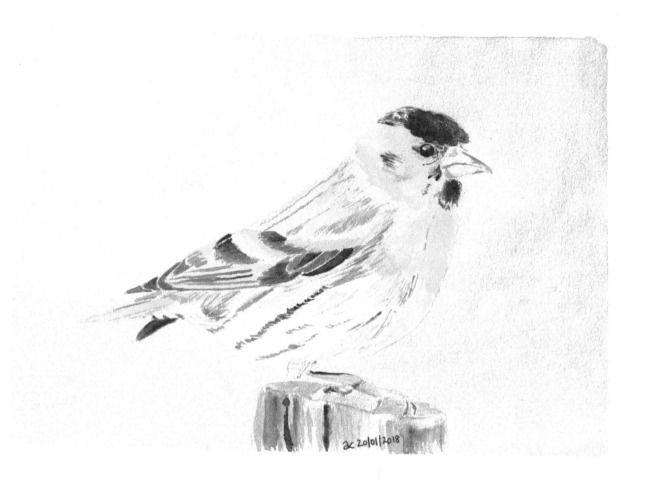

Carduelis spinus

Siskin ◆ Siscín ◆ Erlenzeisig

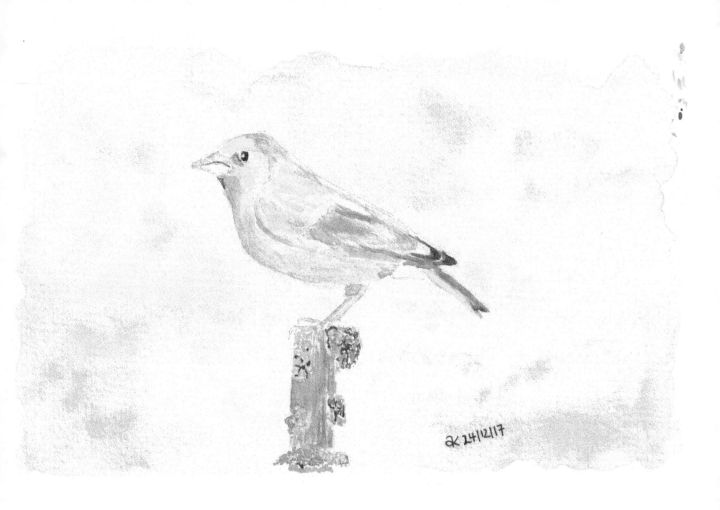

Carduelis chloris

Greenfinch ◆ Glasán darach ◆ Grünfink

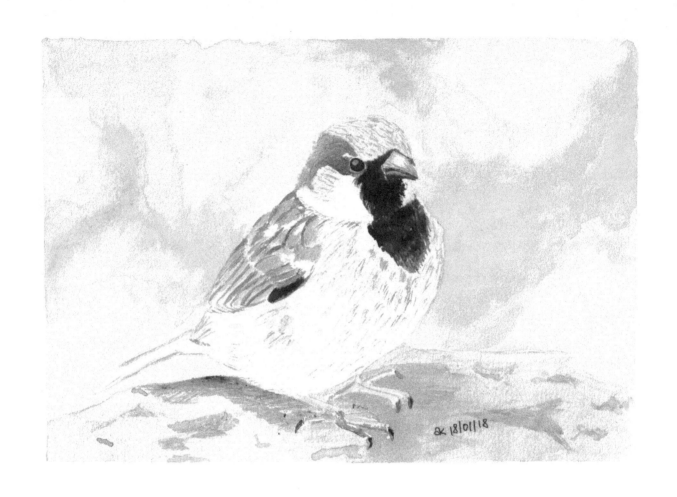

Passer domesticus

House sparrow ◆ Gealbhan binne ◆ Haussperling

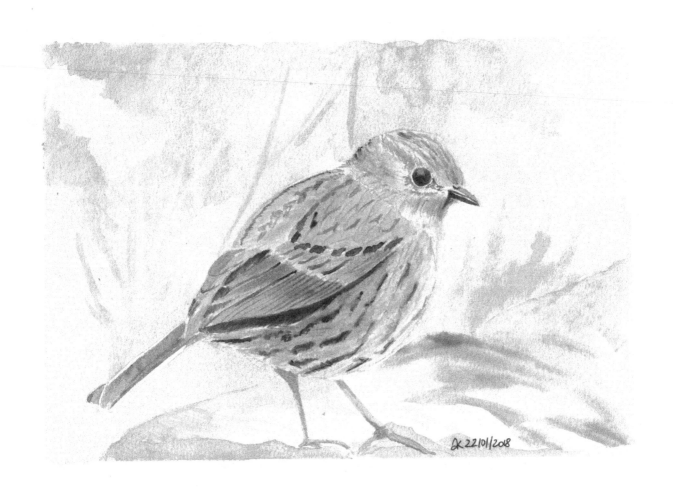

Prunella modularis

Dunnock ◆ Donnóg ◆ Heckenbraunelle

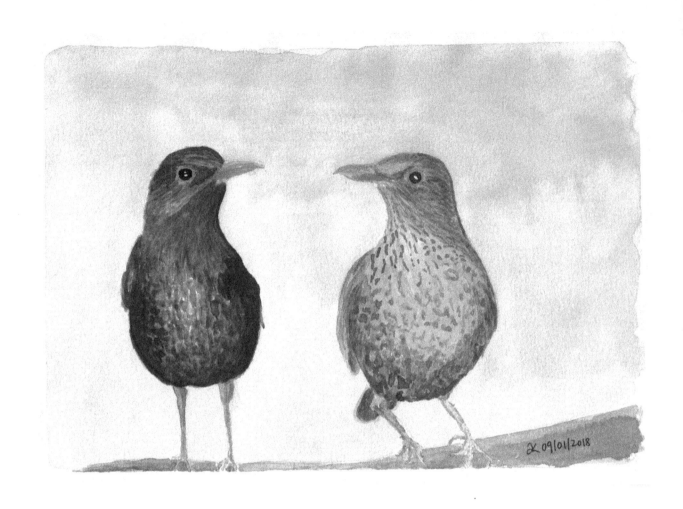

Turdus merula

Blackbird ◆ Lon dubh ◆ Amsel

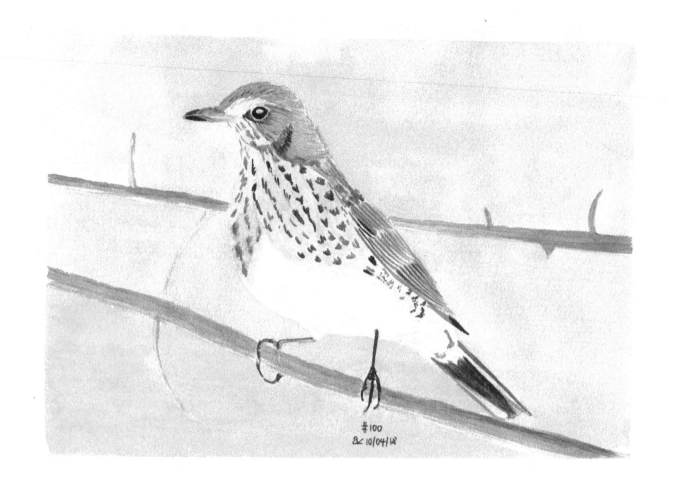

Turdus pilaris

Fieldfare ◆ Sacán ◆ Wacholderdrossel

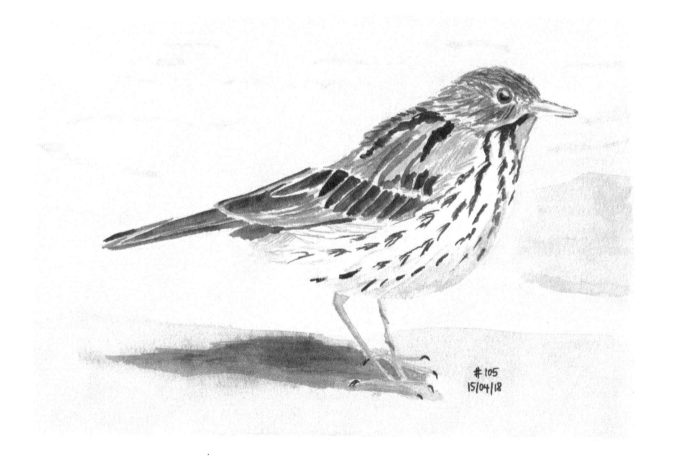

Turdus viscivorus

Mistle thrush ◆ Liatráisc ◆ Misteldrossel

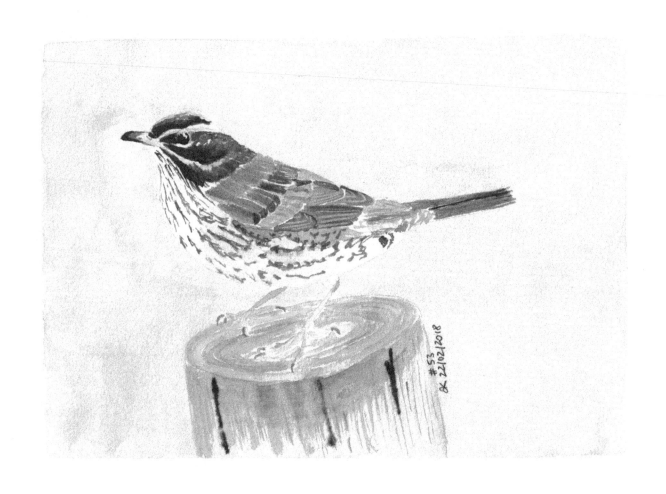

Turdus iliacus

Redwing ◆ Deargán sneachta ◆ Rotdrossel

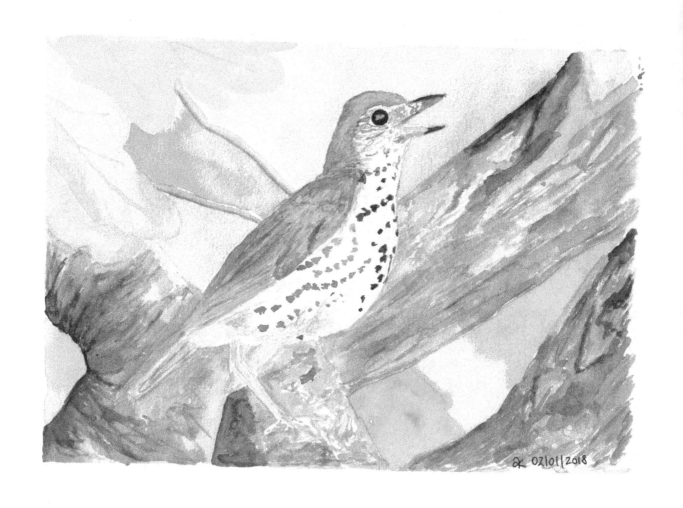

Turdus philomelos

Song thrush ◆ Smólach ceoil ◆ Singdrossel

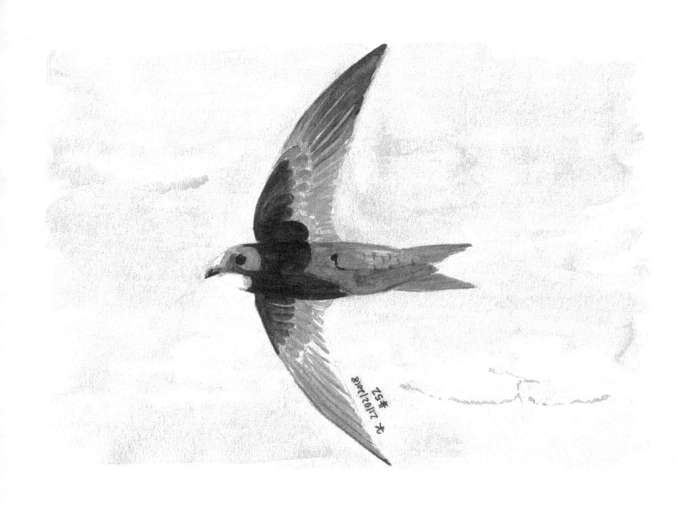

Apus apus

Swift ◆ Gabhlán gaoithe ◆ Mauersegler

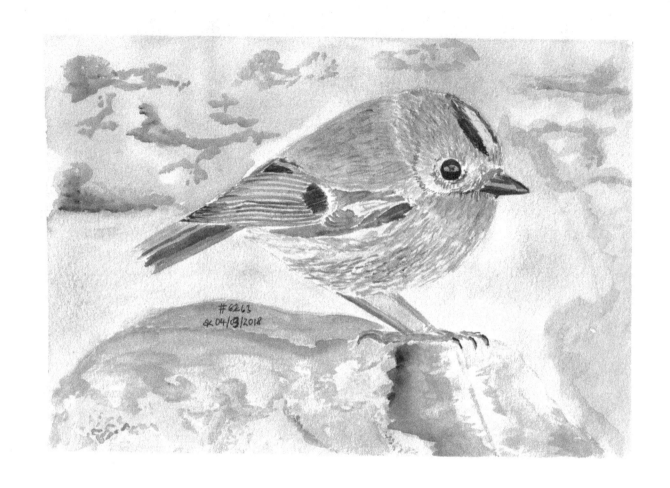

Regulus regulus

Goldcrest ◆ Círbhuí ◆ Wintergoldhähnchen

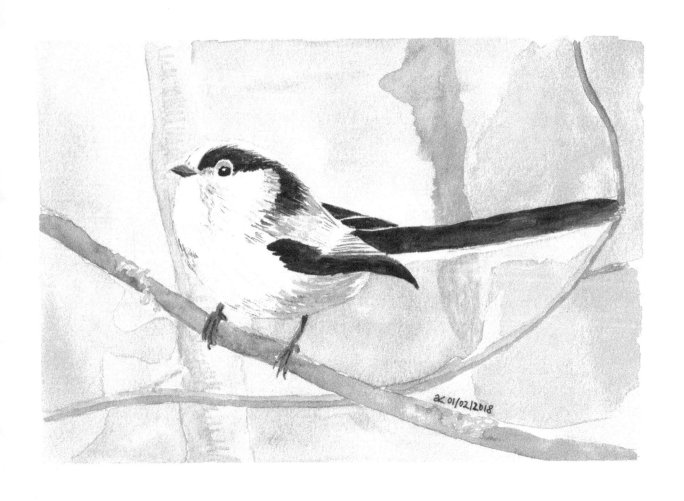

Aegithalos caudatus

Long-tailed tit ◆ Meantán earrfhada ◆ Schwanzmeise

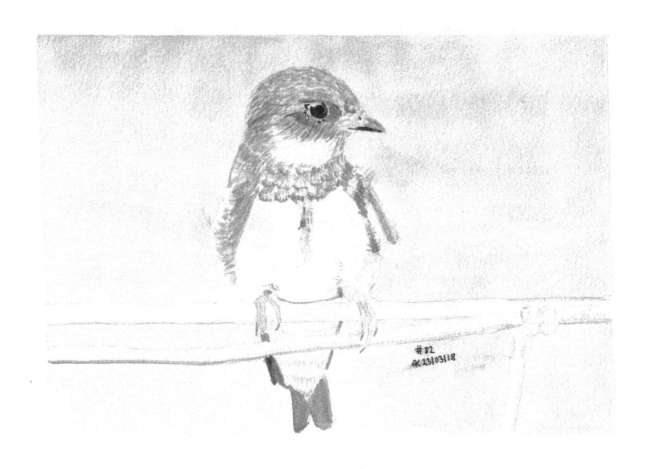

Riparia riparia

Sand martin ♦ Gabhlán gainimh ♦ Uferschwalbe

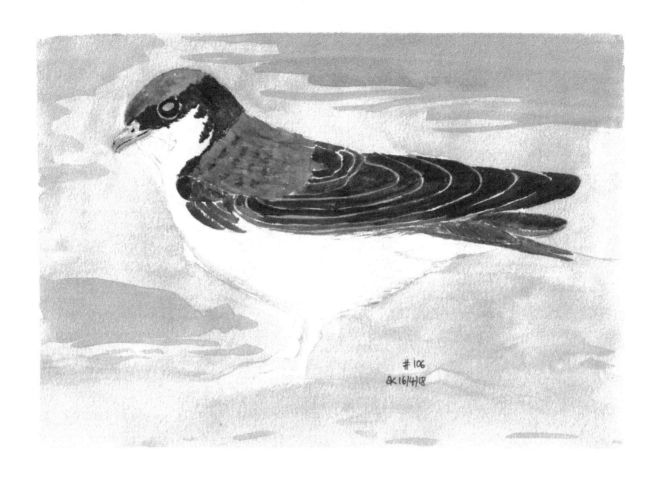

Delichon urbica

House martin ♦ Gabhlán binne ♦ Mehlschwalbe

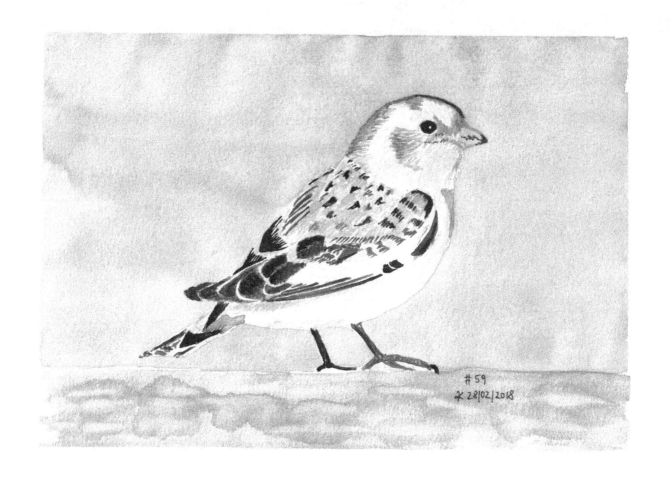

Plectrophenax nivalis

Snow bunting ◆ Gealóg shneachta ◆ Schneeammer

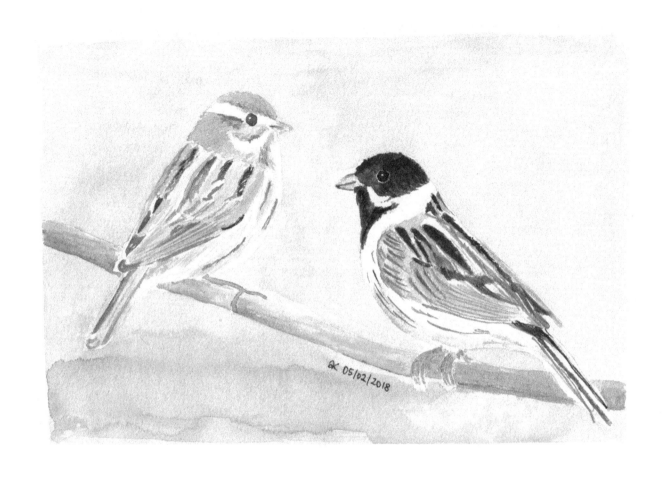

Emberiza schoeniclus

Reed bunting ◆ Gealóg ghiolcaí ◆ Rohrammer

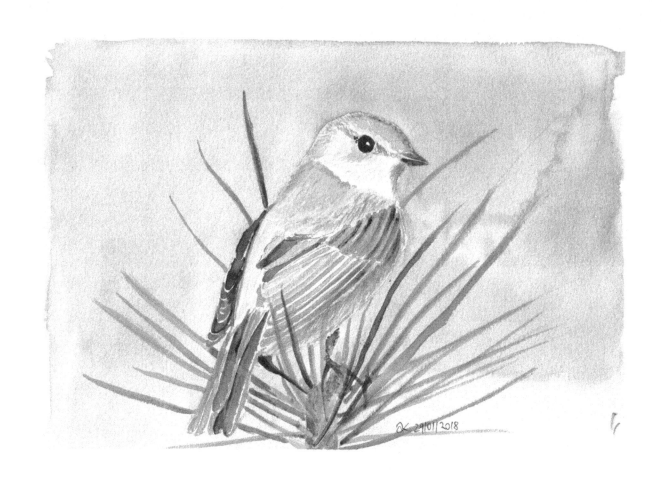

Phylloscopus collybita

Chiffchaff ◆ Tiuf-teaf ◆ Zilpzalp

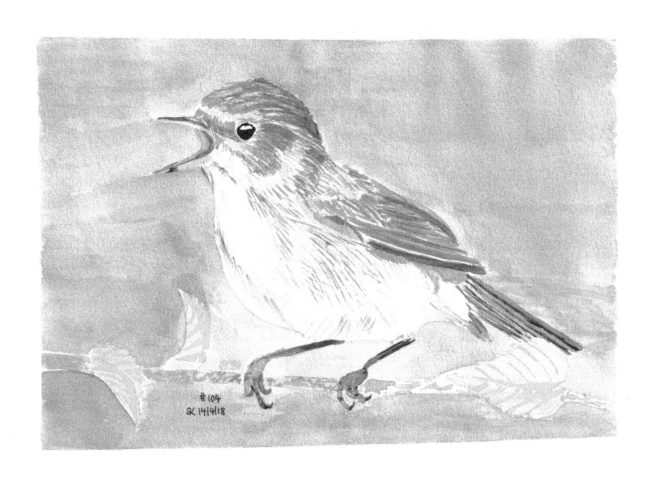

Phylloscopus throchilus

Willow warbler ◆ Ceolaire sailí ◆ Fitislaubsänger

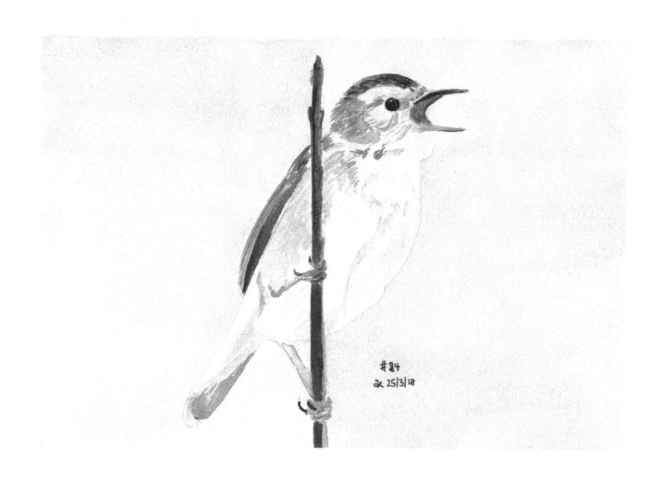

Acrocephalus schoenobaenus

Sedge warbler ♦ Ceolare cíbe ♦ Schilfrohrsänger

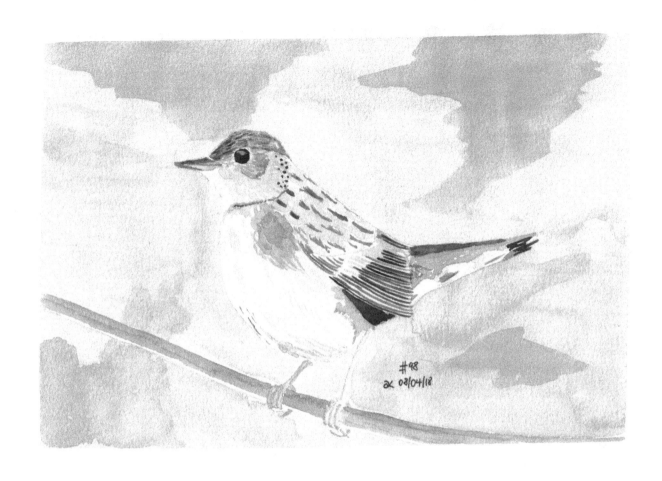

Locustella naevia

Grasshopper warbler ◆ Ceolaire casarnaí ◆ Feldschwirl

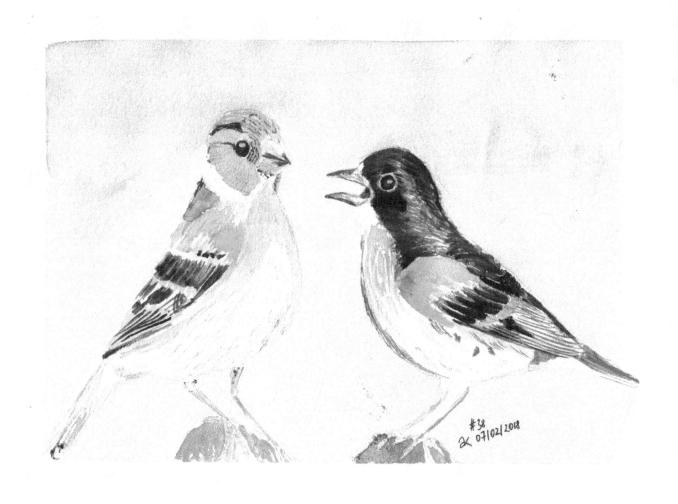

Fringilla montifringilla

Brambling ◆ Breacán ◆ Bergfink

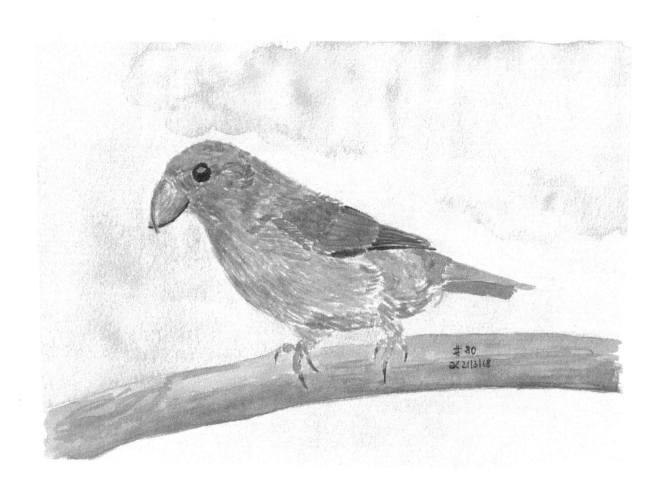

Loxia curvirostra

Red crossbill ◆ Crosghob ◆ Fichtenkreuzschnabel

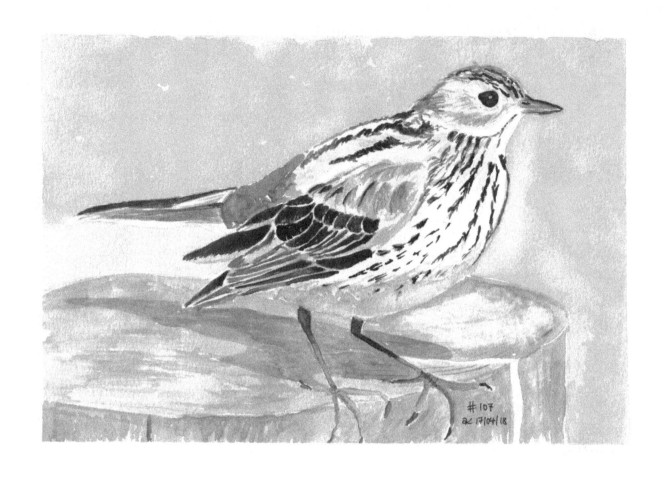

Anthus pratensis

Meadow pipit ◆ Riabhóg mhóna ◆ Wiesenpieper

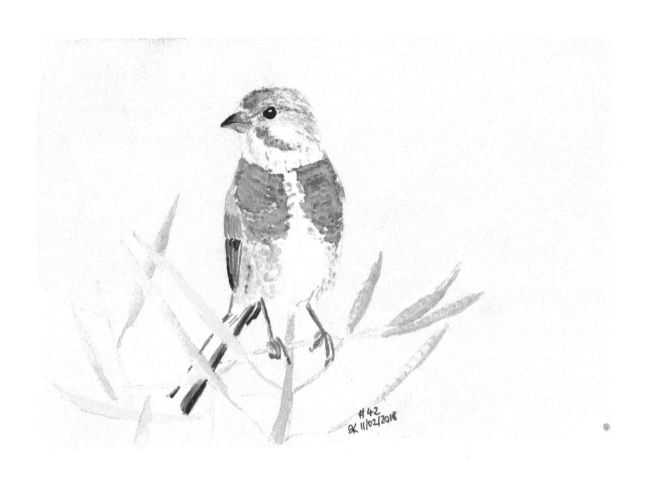

Carduelis cannabina

Linnet ◆ Gleoiseach ◆ Bluthänfling

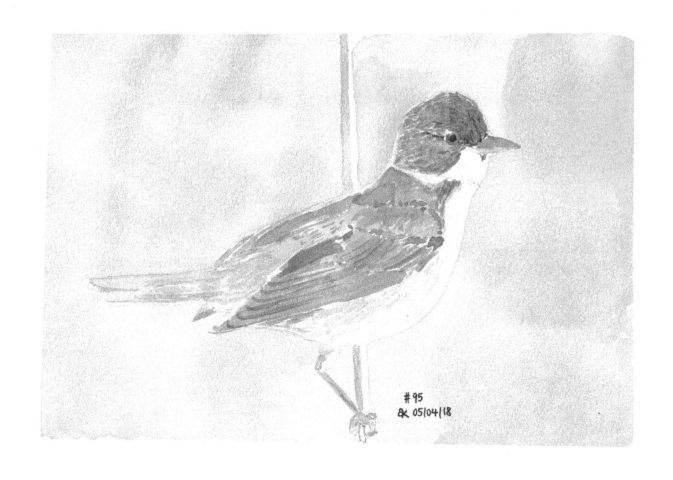

Sylvia communis

Whitethroat ◆ Gilphíb ◆ Dorngrasmücke

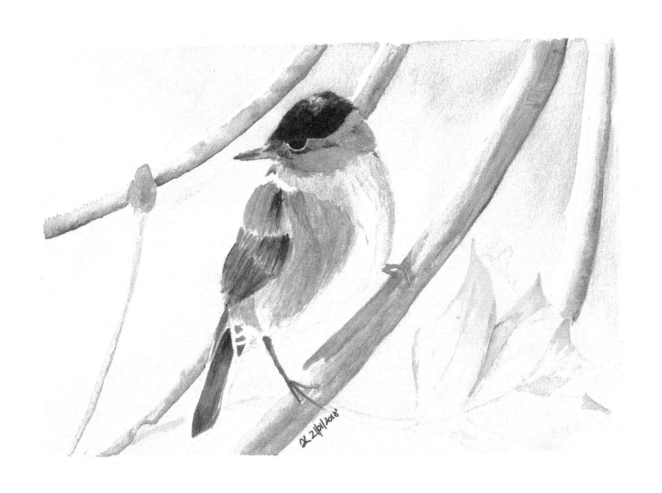

Sylvia atricapilla

Blackcap ◆ Caipín dubh ◆ Mönchsgrasmücke

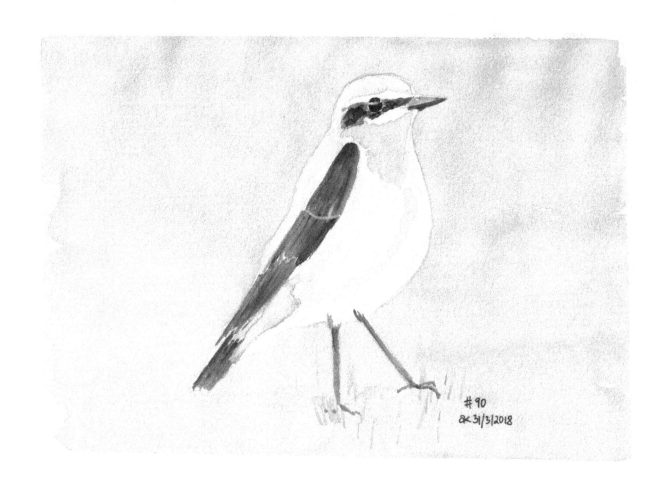

Oenanthe oenanthe

Wheatear ◆ Clochrán ◆ Steinschmätzer

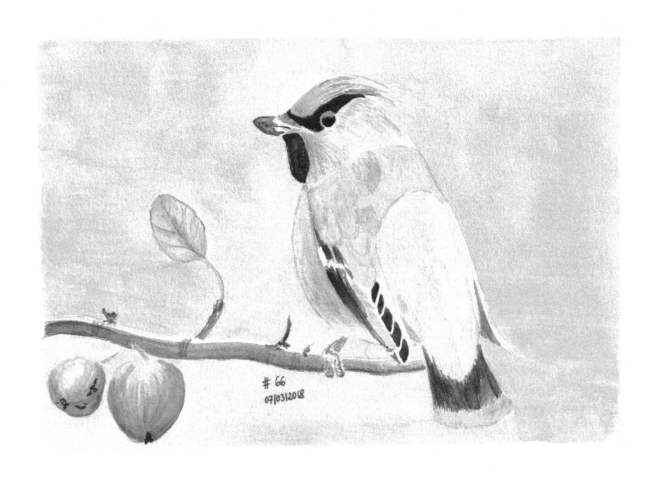

Bombycilla garrulus

Waxwing ◆ Síodeiteach ◆ Seidenschwanz

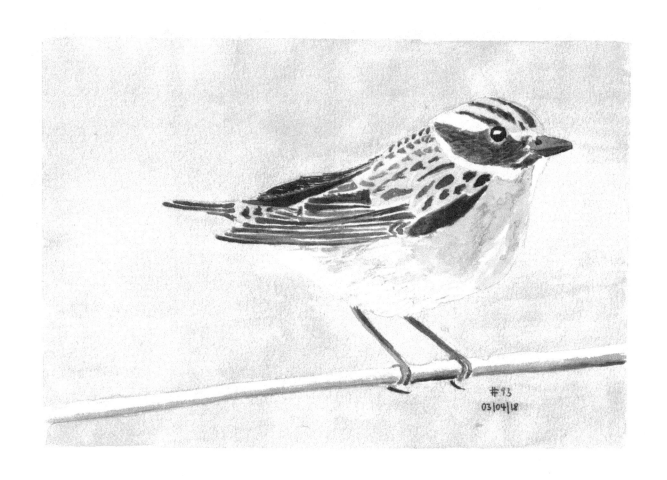

Saxicola rubetra

Whinchat ◆ Caislín aitinn ◆ Braunkehlchen

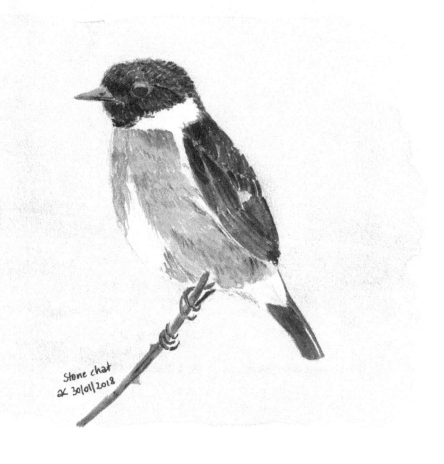

Saxicola rubicola

Stonechat ◆ Caislín cloch ◆ Schwarzkehlchen

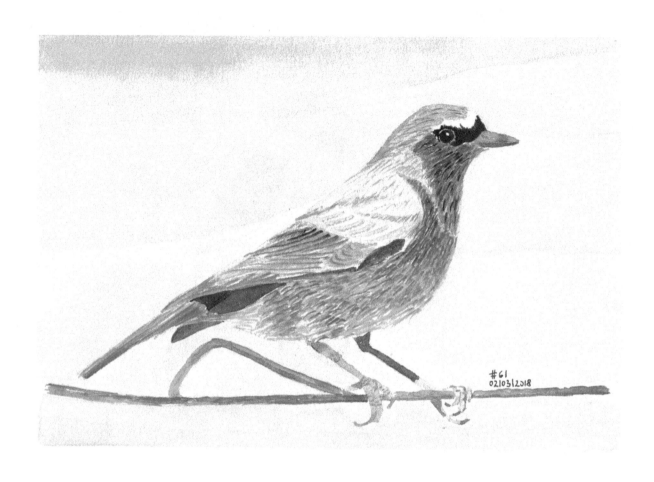

Phoenicurus phoenicurus

Redstart ◆ Earrdheargán ◆ Gartenrotschwanz

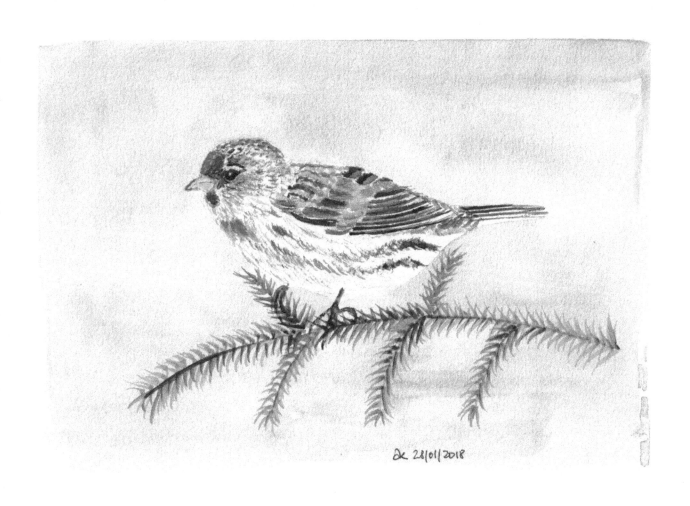

Carduelis flammea

Redpoll ◆ Deargéadan ◆ Birkenzeisig

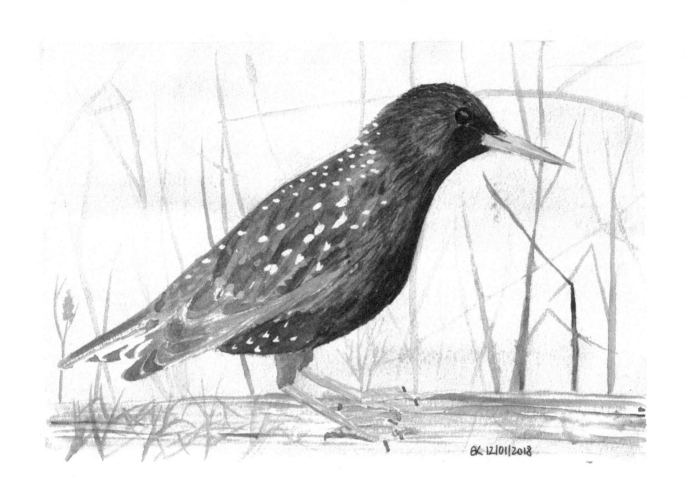

Sturnus vulgaris

Starling ◆ Druid ◆ Star

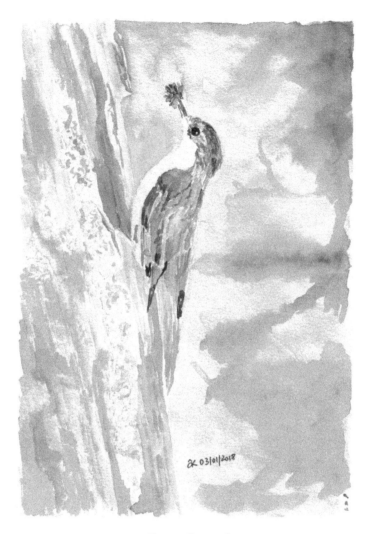

Certhia familiaris

Treecreeper ◆ Snag ◆ Waldbaumläufer

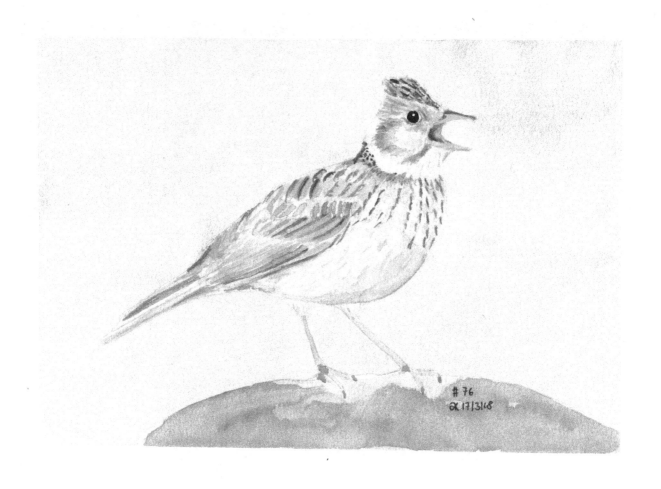

Alauda arvensis

Skylark ◆ Fuiseog ◆ Feldlerche

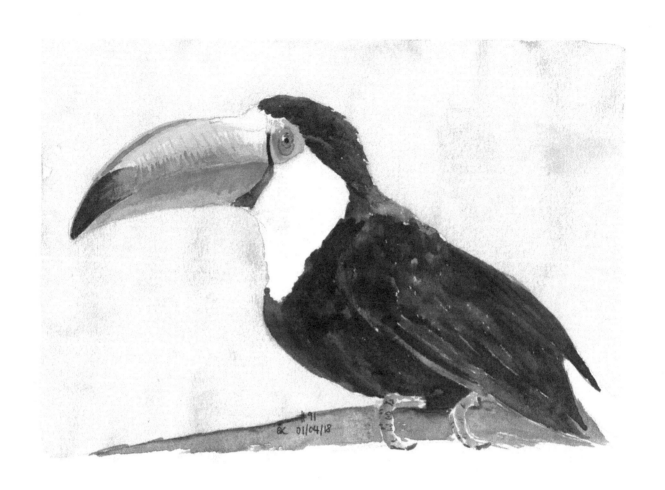

Ramphastos toco

Toco toucan ♦ Tucán ♦ Riesentukan

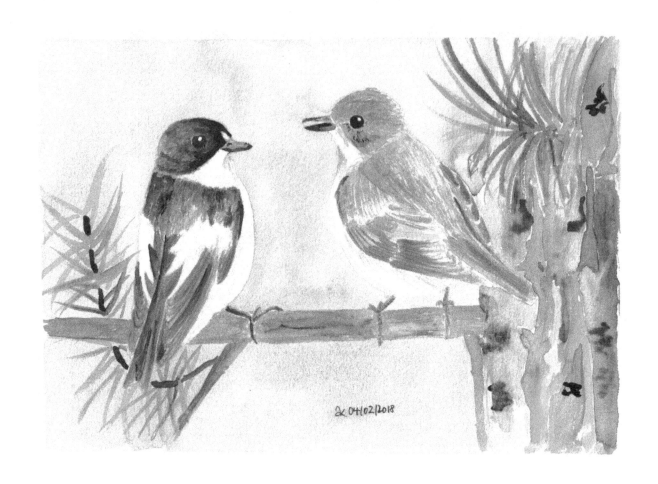

Ficedula hypoleuca

Pied flycatcher ◆ Cuilsealgaire alabhreac ◆ Trauerschnäpper

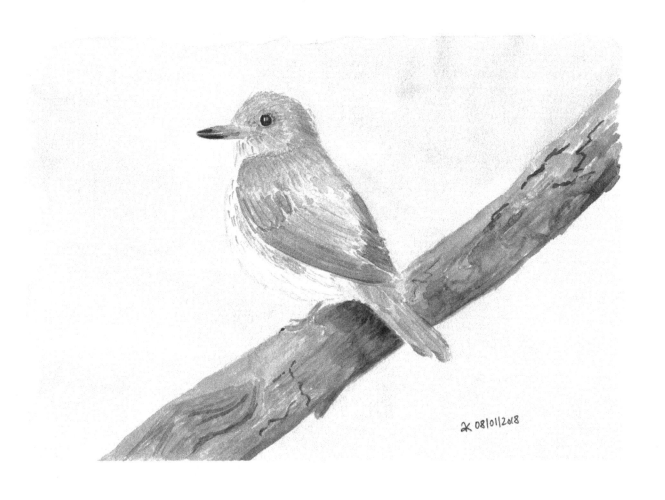

Muscicapa striata

Spotted flycatcher ◆ Cuilsealgaire liath ◆ Grauschnäpper

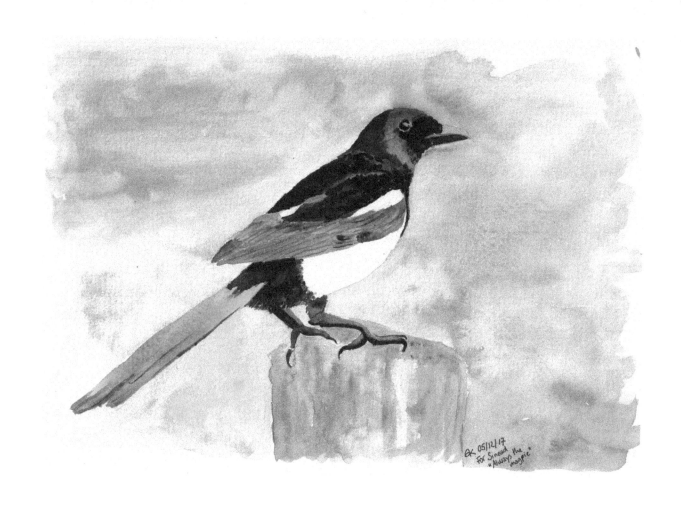

Pica pica

Magpie ◆ Snag breac ◆ Elster

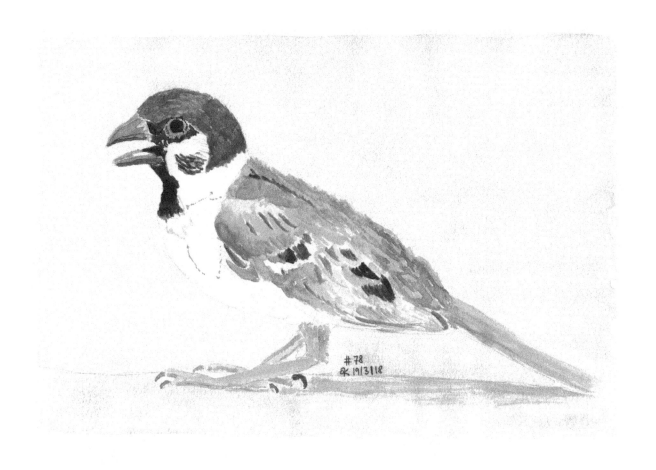

Passer montanus

Tree sparrow ♦ Gealbhan crainn ♦ Feldsperling

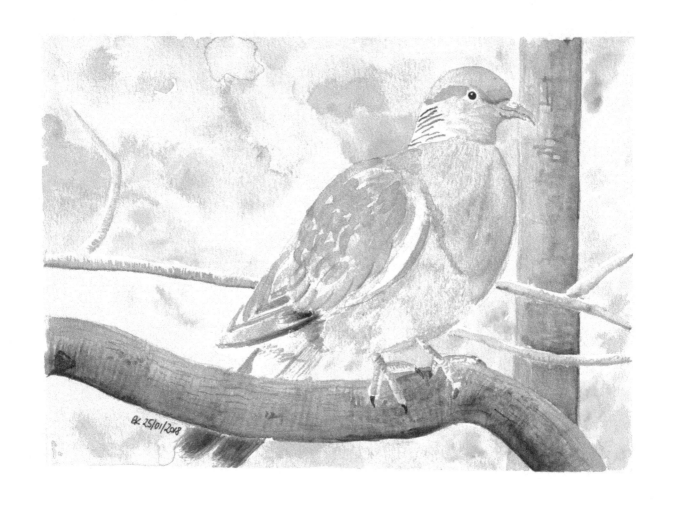

Columba palumbus

Wood pigeon ◆ Colm coille ◆ Ringeltaube

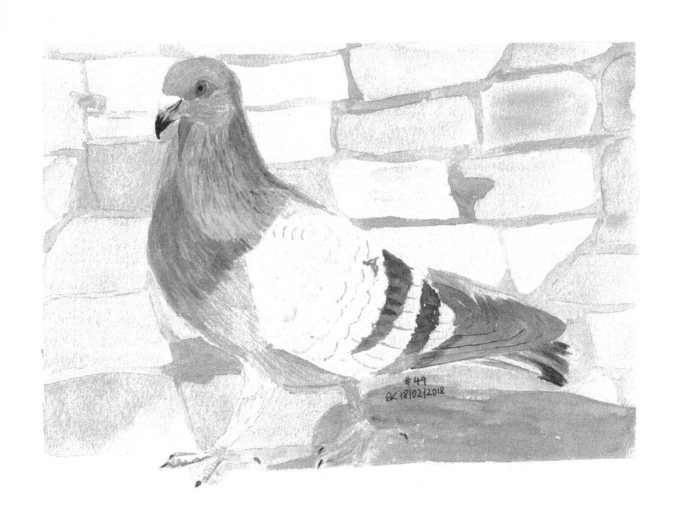

Columba livia

Rock pigeon ◆ Colm aille ◆ Felsentaube

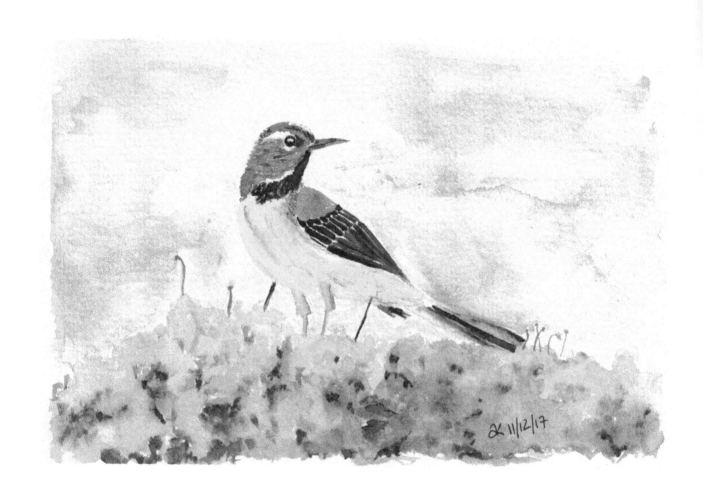

Motacilla cinerea

Grey wagtail ♦ Glasóg liath ♦ Bergstelze

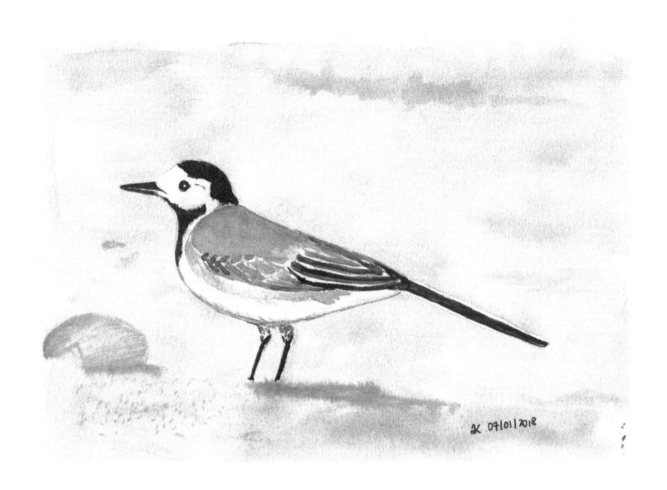

Motacilla alba

Pied wagtail ◆ Glasóg shráide ◆ Bachstelze

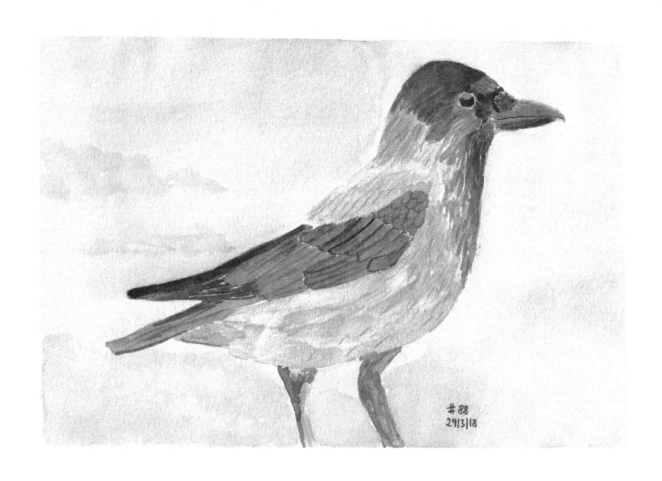

Corvus corone cornix

Hooded crow ♦ Caróg liath ♦ Nebelkrähe

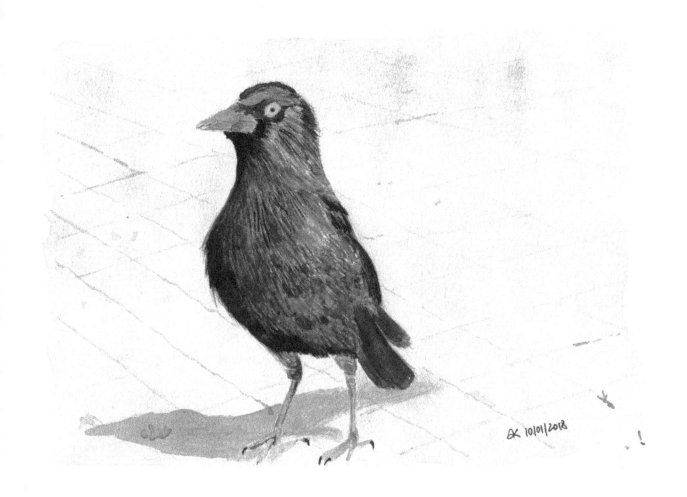

Corvus monedula

Jackdaw ◆ Cág ◆ Dohle

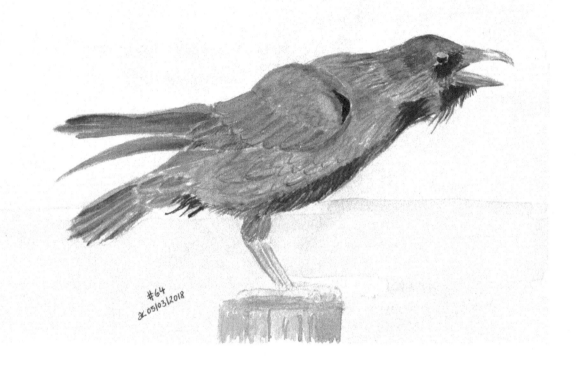

Corvus corax

Raven ◆ Fiach dubh ◆ Kolkrabe

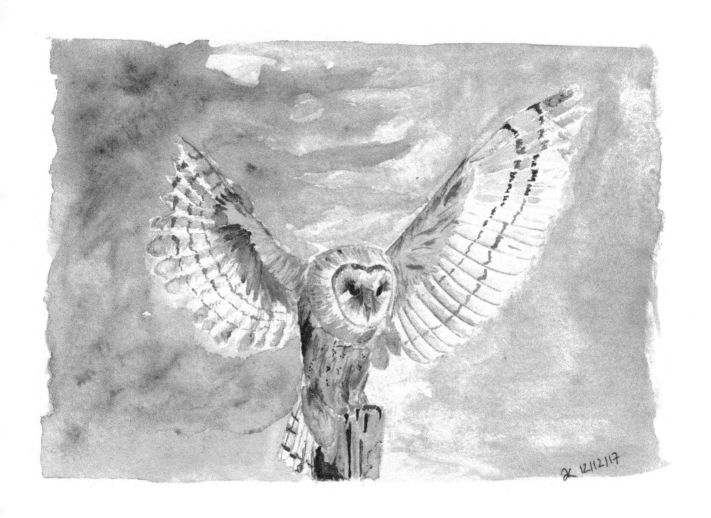

Tyto alba

Barn owl ♦ Scréachóg reilige ♦ Schleiereule

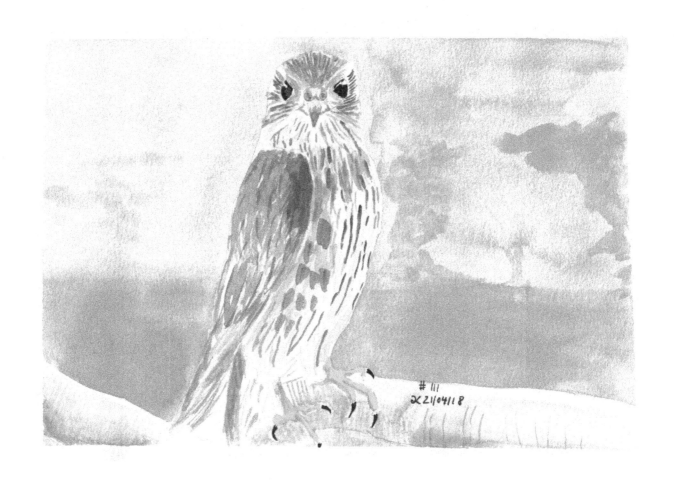

Falco columbarius

Merlin ♦ Meirliún ♦ Zwergfalke

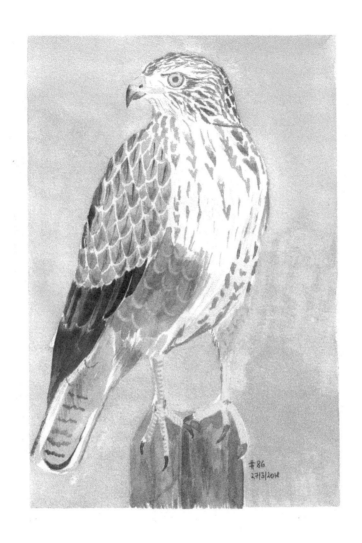

Buteo buteo

Buzzard ◆ Clamhán ◆ Bussard

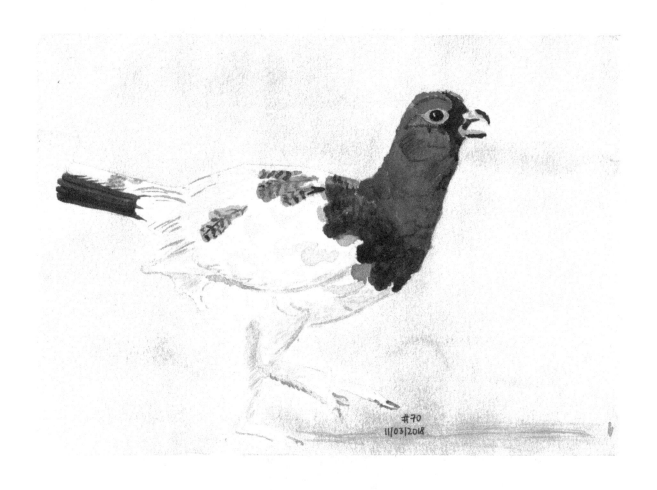

Lagopus lagopus

Willow ptarmigan ◆ Tarmachan ◆ Moorschneehuhn

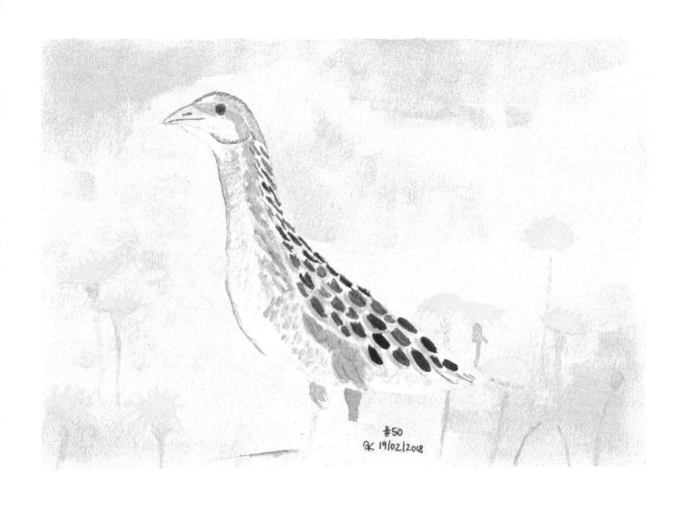

Crex crex

Corn crake ◆ Traonach ◆ Wachtelkönig

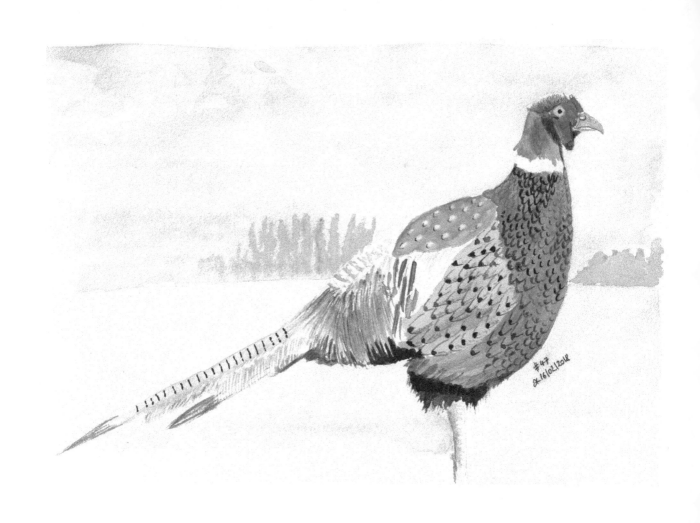

Phasianus colchicus

Pheasant ◆ Piasún ◆ Fasan

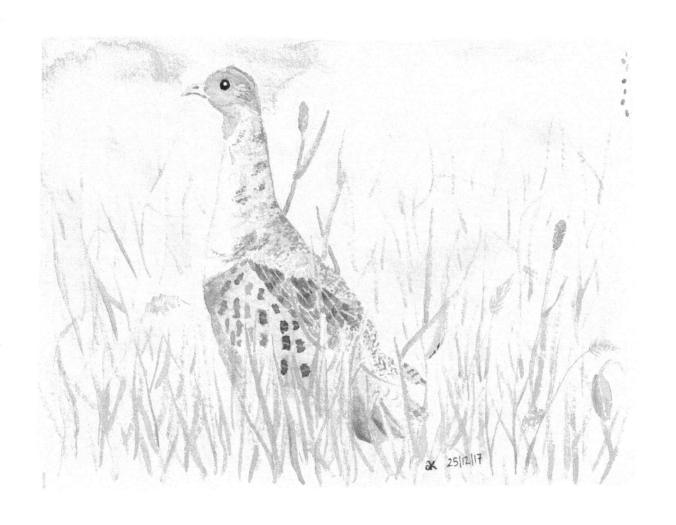

Perdix perdix

Grey partridge ◆ Patraisc ◆ Rebhuhn

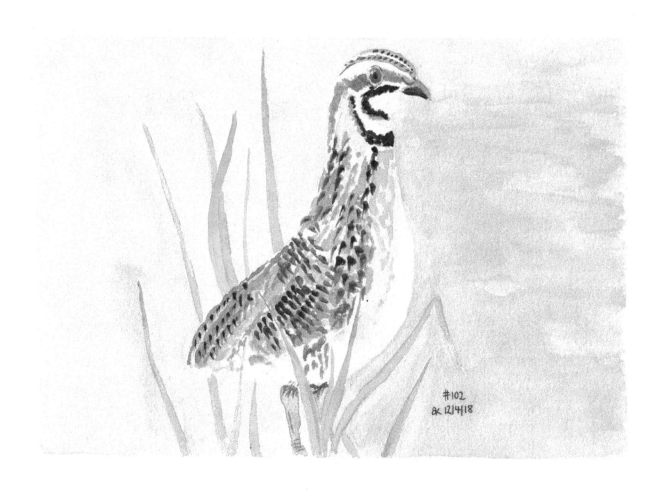

Coturnix coturnix

Quail ◆ Gearg ◆ Wachtel

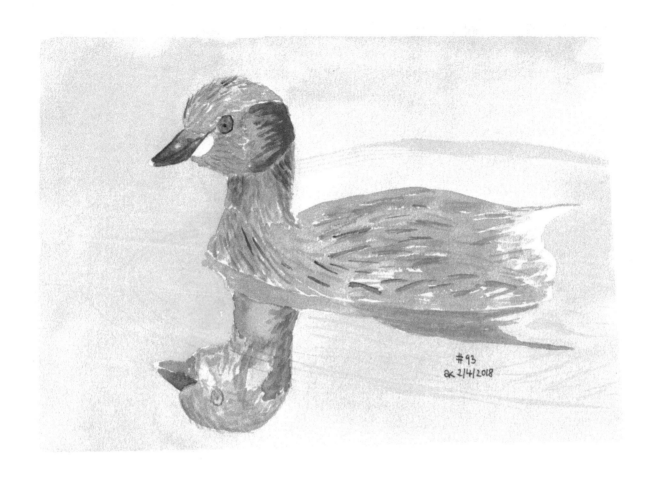

Tachybabtus ruficollis

Little grebe ◆ Spágaire tonn ◆ Zwergtaucher

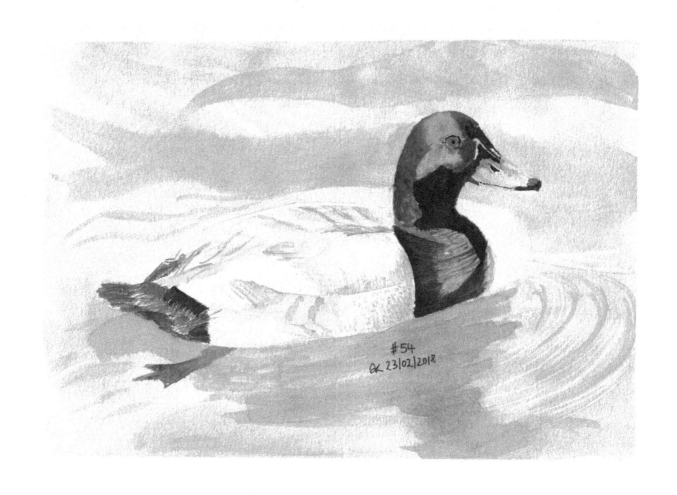

Aythya ferina

Pochard ◆ Póiseard ◆ Tafelente

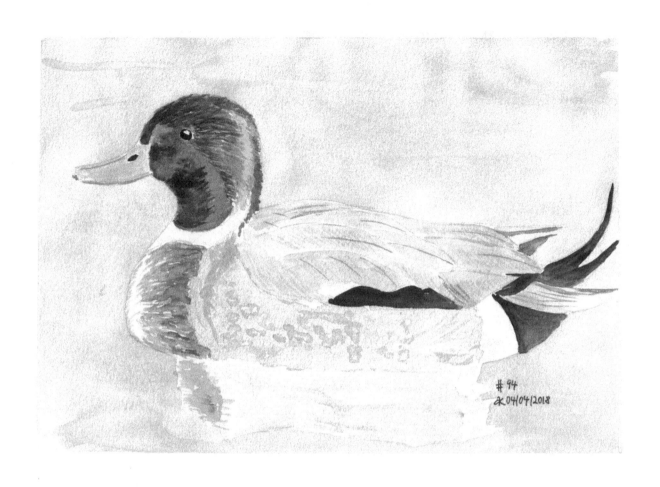

Anas acuta

Pintail ◆ Biorearrach ◆ Spießente

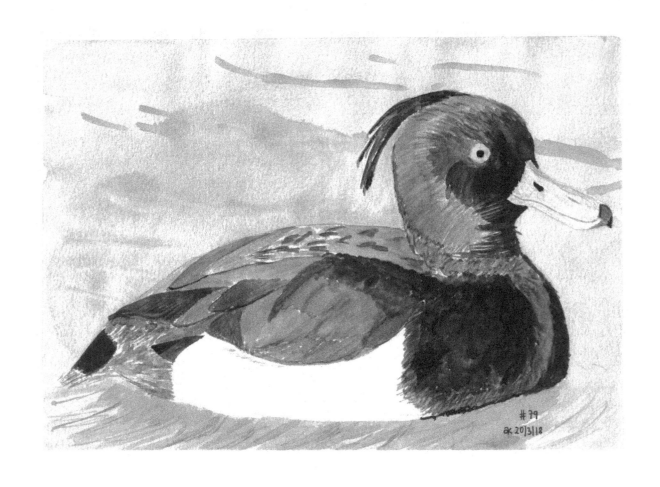

Aythya fuligula

Tufted duck ◆ Lacha bhadánach ◆ Reiherente

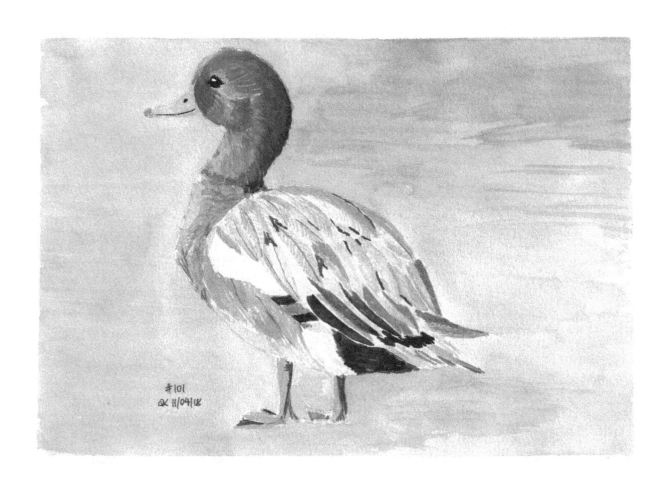

Anas penelope

Wigeon ◆ Lacha Rua ◆ Pfeifente

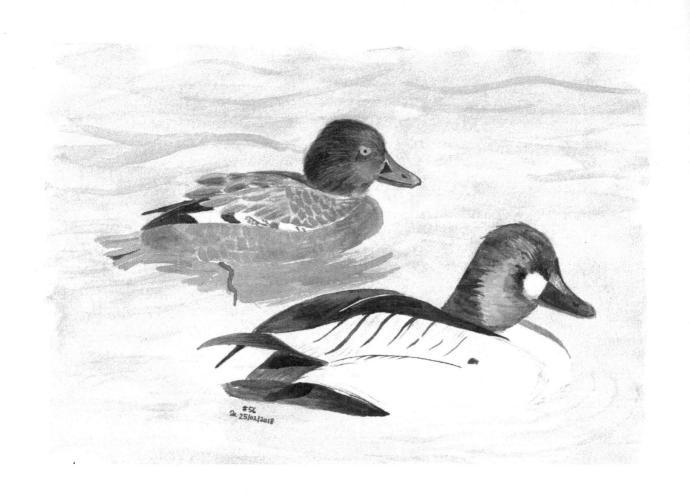

Bucephala clangula

Goldeneye ◆ Órshúileach ◆ Schellente

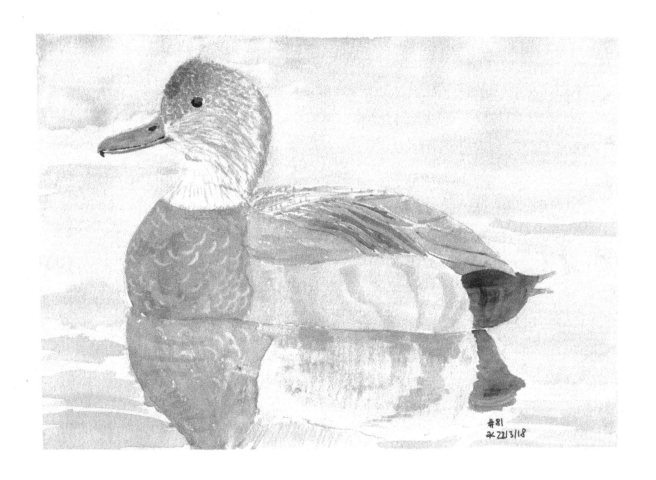

Anas strepera

Gadwall ◆ Gadual ◆ Schnatterente

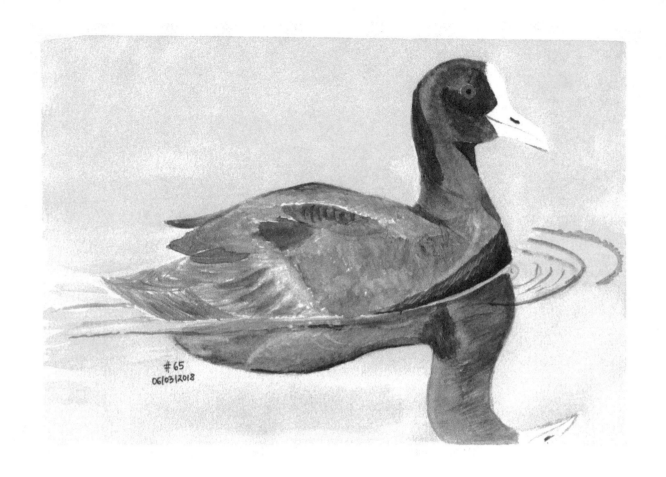

Fulica atra

Eurasian coot ◆ Cearc cheannann ◆ Blesshuhn

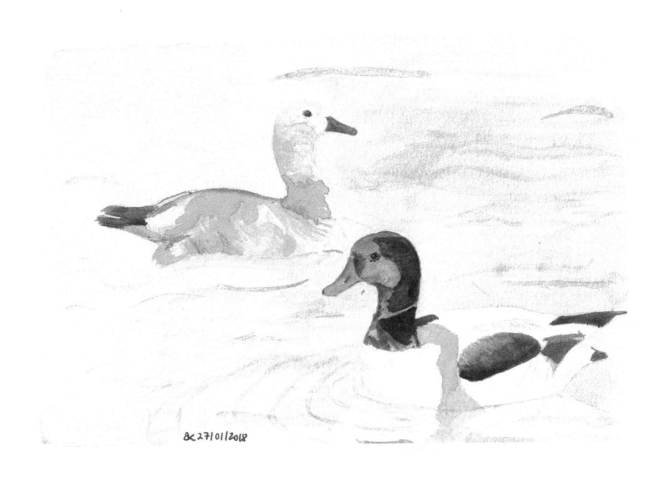

Tadorna tadorna

Shelduck ◆ Seil-lacha ◆ Brandgans

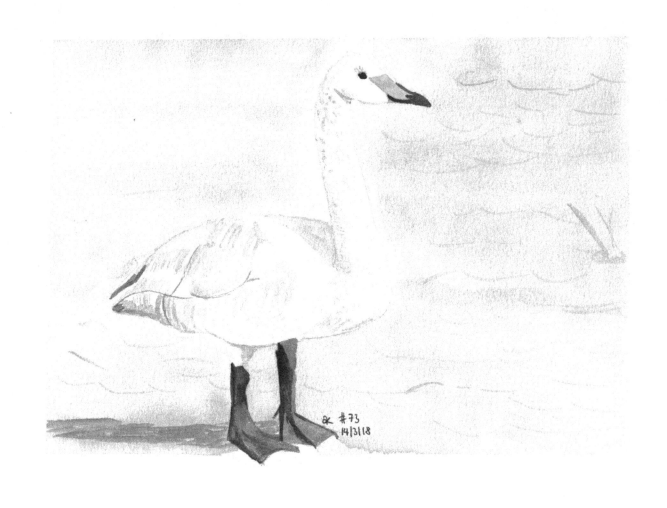

Cygnus cygnus

Whooper swan ♦ Eala ghlórach ♦ Singschwan

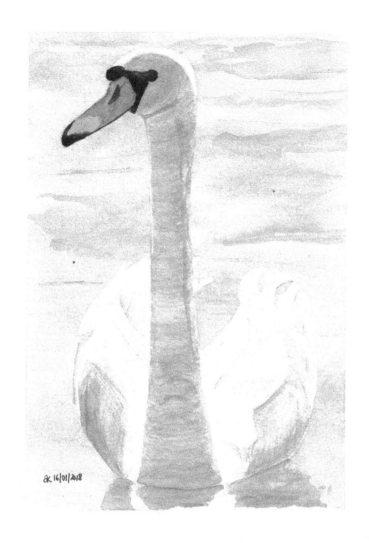

Cygnus olor

Mute swan ◆ Eala balbh ◆ Höckerschwan

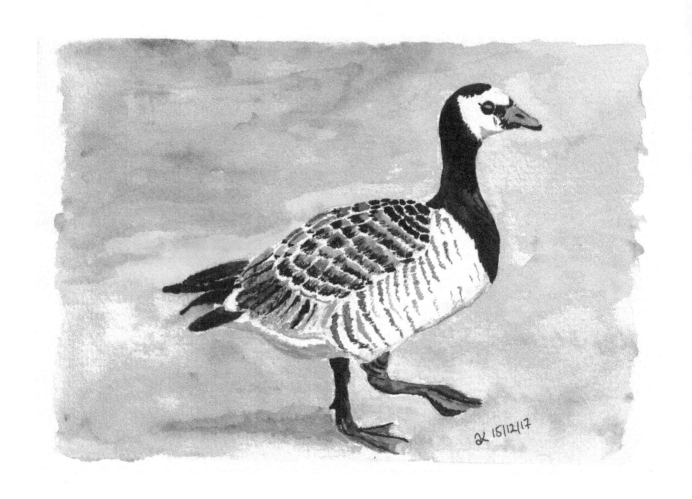

Branta leucopsis

Barnacle goose ◆ Gé ghiúrainn ◆ Nonnengans

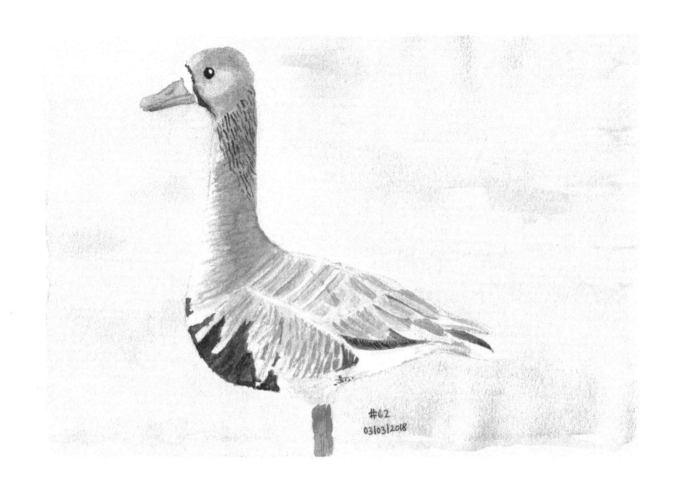

Anser albifrons

White-fronted goose ◆ Gé bhánéadanach ◆ Blessgans

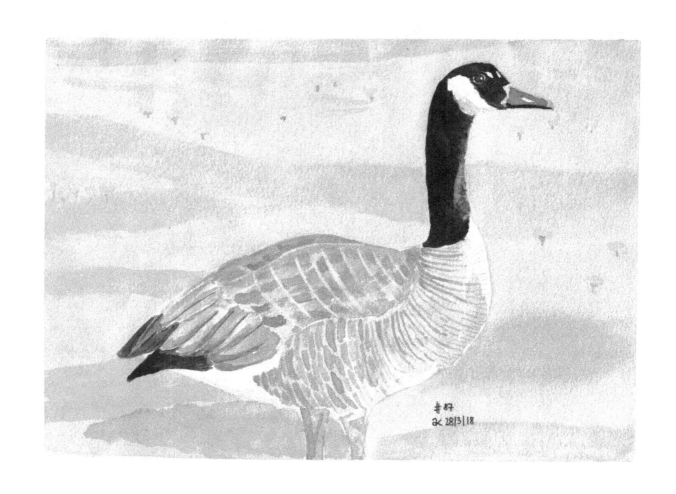

Branta canadensis

Canada goose ◆ Gé cheanadach ◆ Kanadagans

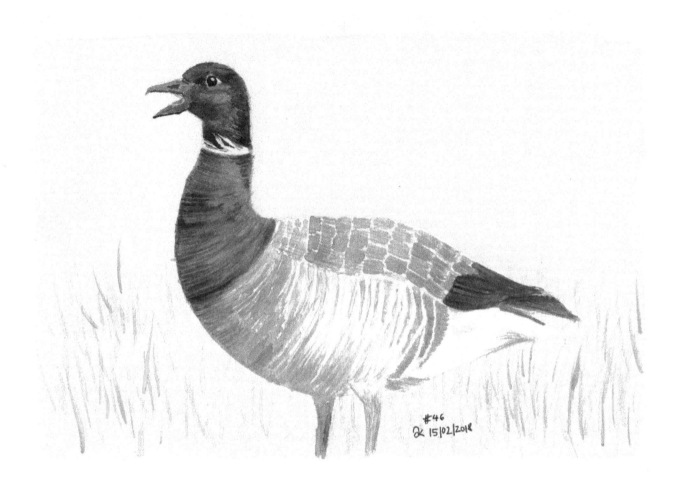

Branta bernicla

Brent goose ◆ Gé cadhan ◆ Ringelgans

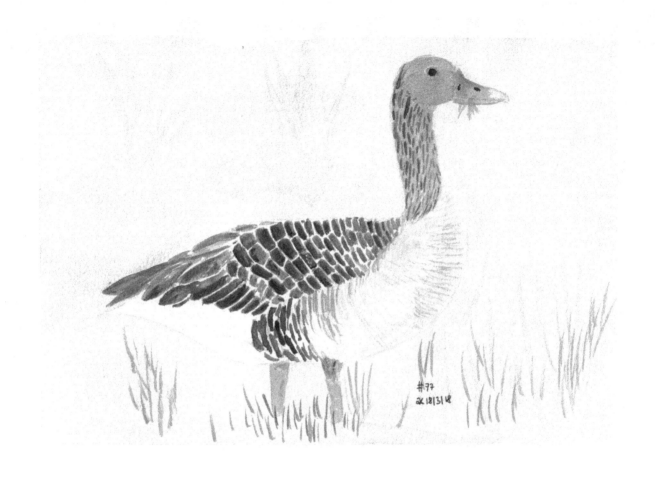

Anser anser

Greylag goose ◆ Gé ghlas ◆ Graugans

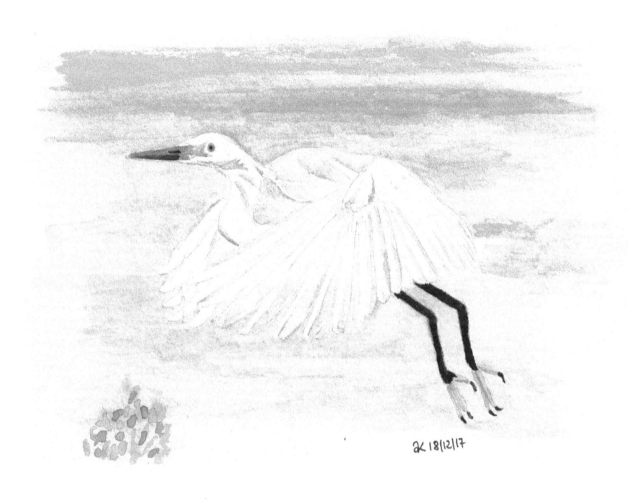

Egretta garzetta

Little egret ◆ Éigrit bheag ◆ Seidenreiher

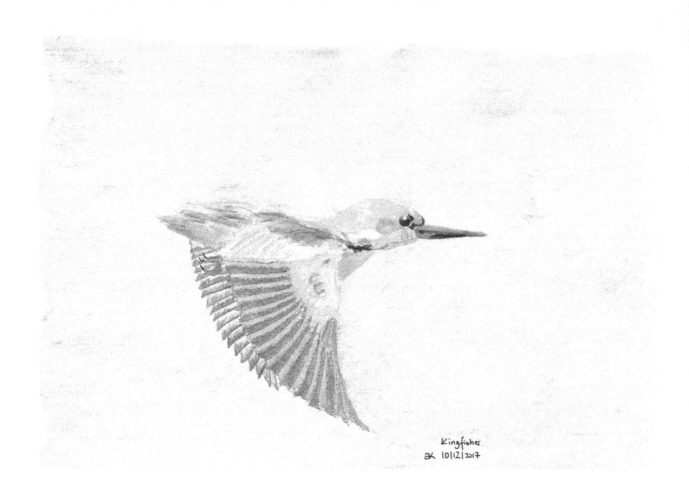

Alcedo atthis

Kingfisher ◆ Cruidín ◆ Eisvogel

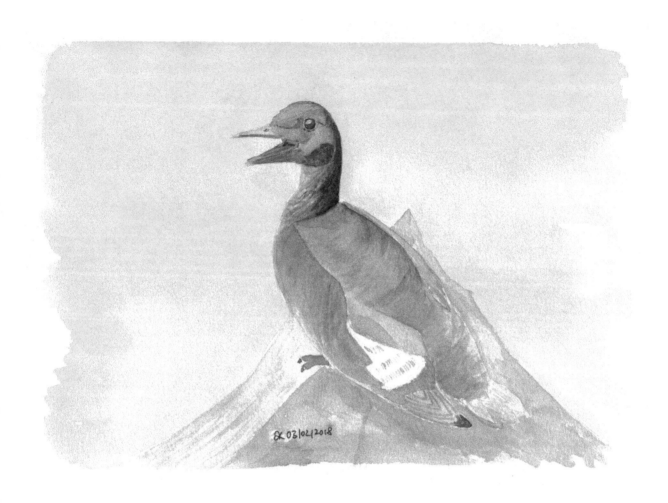

Cepphus grylle

Black guillemot ◆ Forache dhubh ◆ Gryllteiste

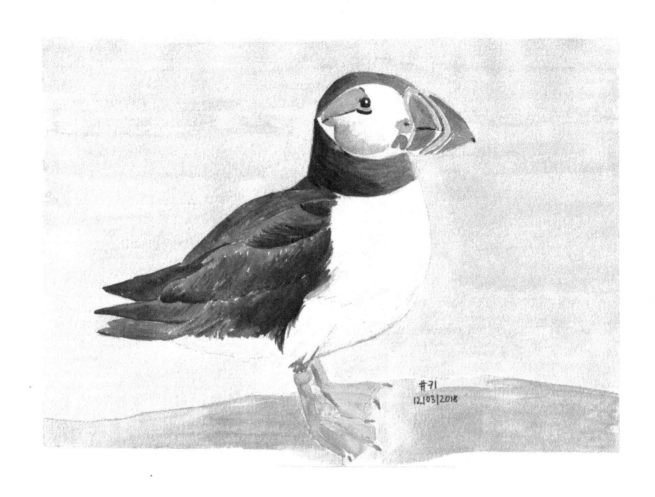

Fratercula arctica

Puffin ◆ Puifín ◆ Papageitaucher

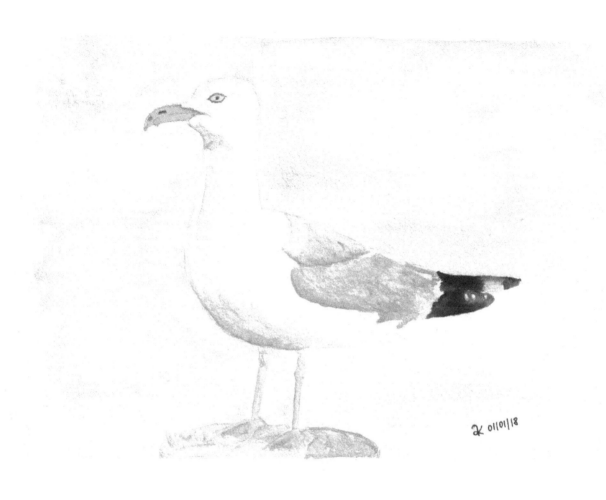

Larus argentatus

Herring gull ◆ Faoileán scadán ◆ Silbermöwe

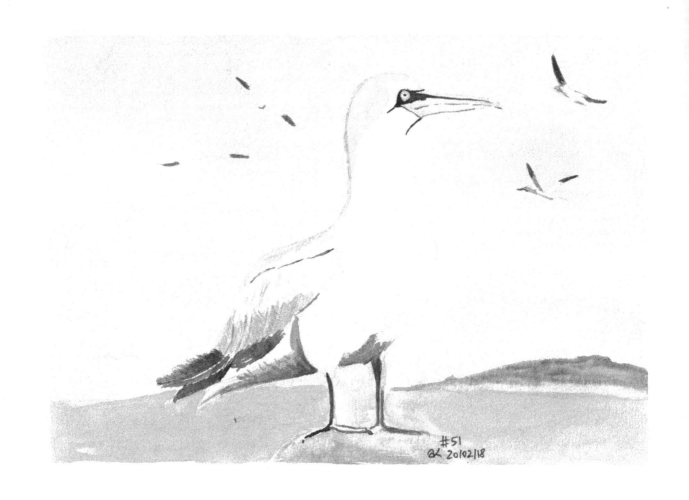

Morus bassanus

Gannet ◆ Gainéad ◆ Basstölpel

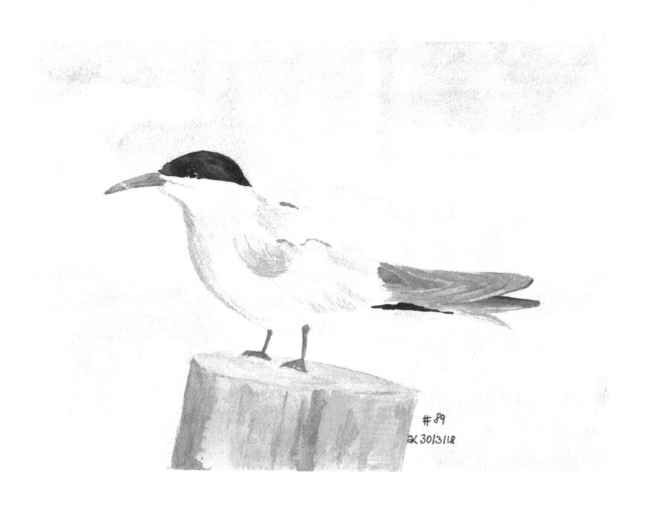

Sterna hirundo

Common tern ◆ Geabhróg ◆ Flussseeschwalbe

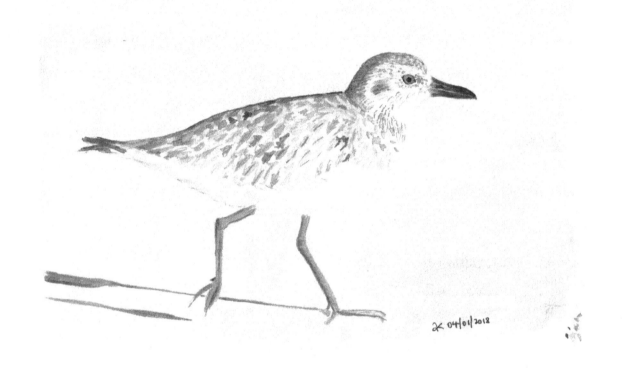

Pluvialis squatarola

Grey plover ♦ Feadóg ghlas ♦ Kiebitzregenpfeifer

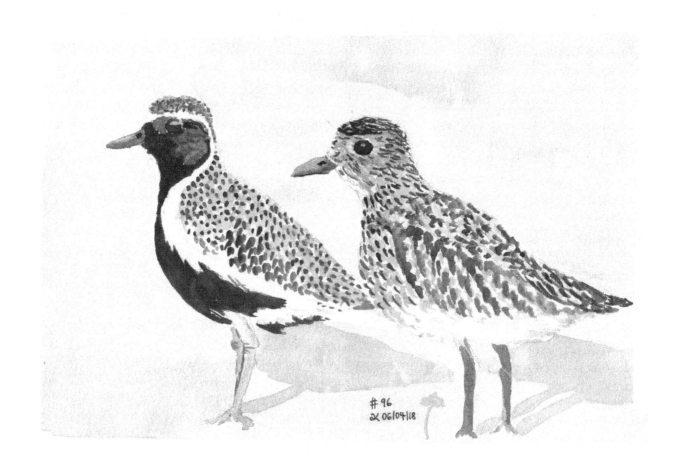

Pluvialis apricaria

Golden plover ◆ Feadóg bhuí Áiseach ◆ Goldregenpfeifer

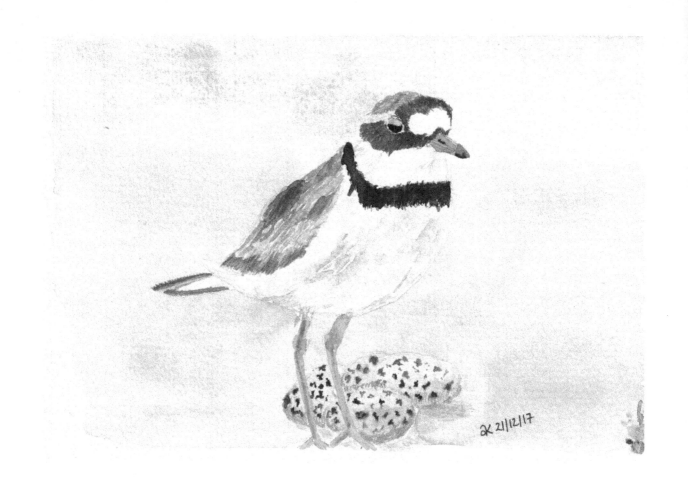

Charadrius hiaticula

Ringed plover ♦ Feadóg chladaigh ♦ Sandregenpfeifer

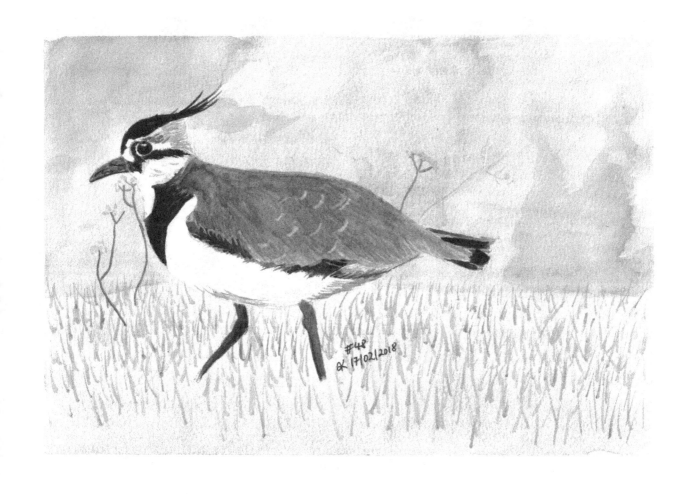

Vanellus vanellus

Northern lapwing ◆ Pilibín ◆ Kiebitz

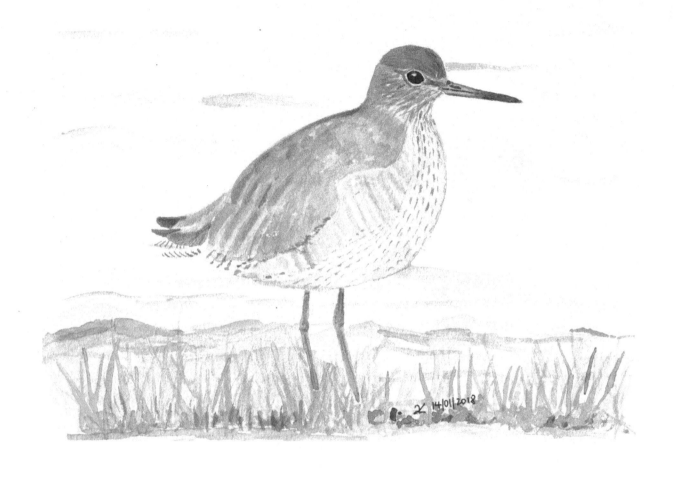

Tringa totanus

Common redshank ♦ Cosdeargán ♦ Rotschenkel

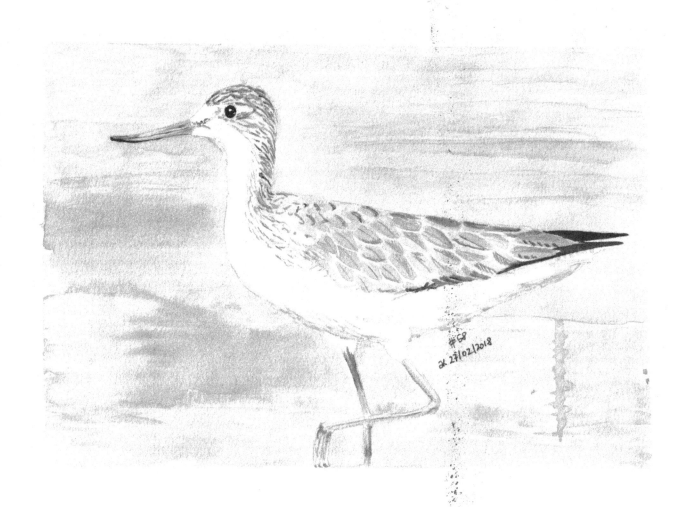

Tringa nebularia

Common greenshank ♦ Laidhrín glas ♦ Grünschenkel

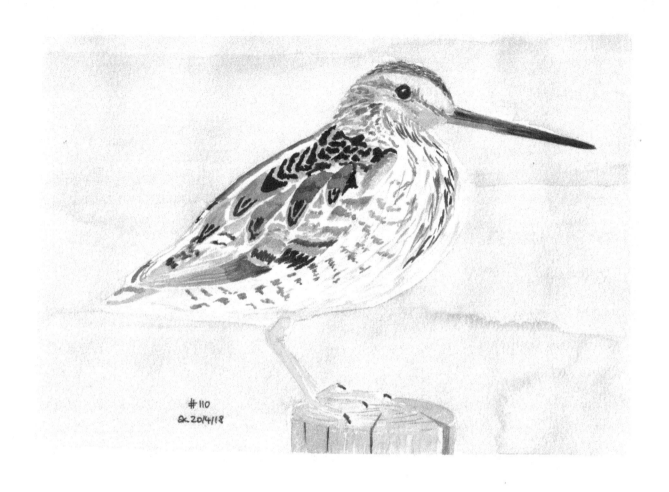

Gallinago gallinago

Snipe ◆ Naoscach ◆ Bekassine

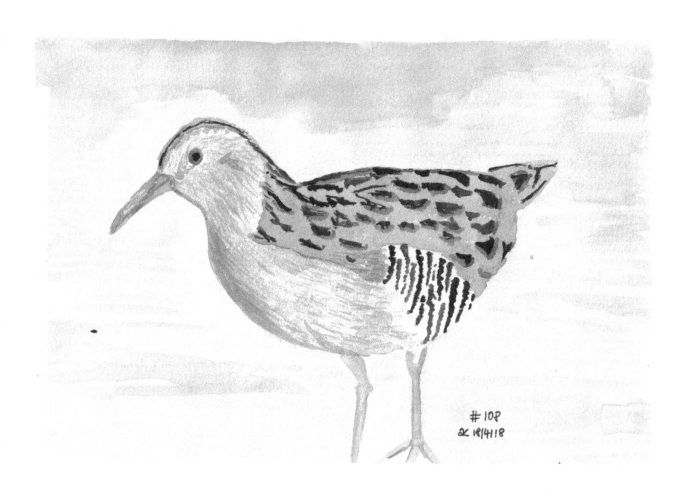

Rallus aquaticus

Water rail ◆Ralóg uisce ◆ Wasserralle

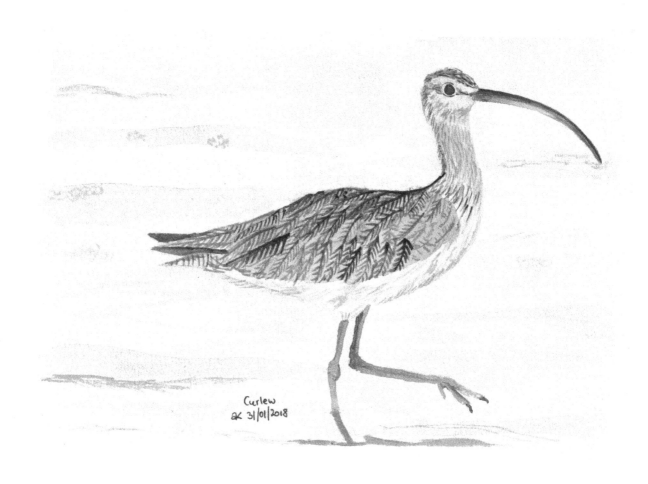

Numenius arquata

Curlew ♦ Crotach ♦ Großer Brachvogel

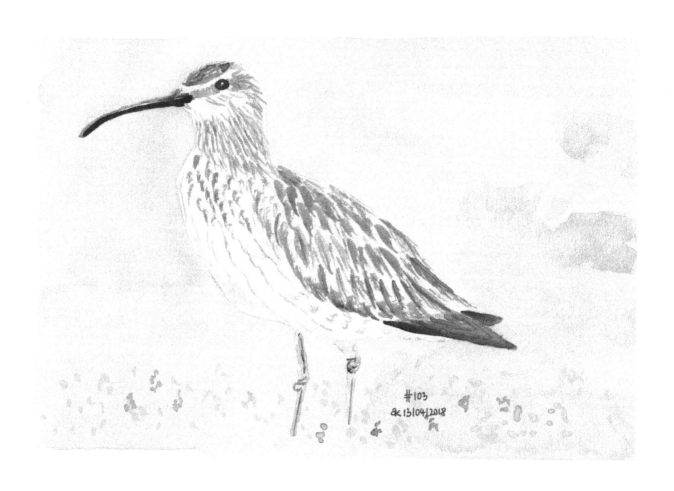

Numenius phaeopus

Whimbrel ♦ Crotach eanaigh ♦ Regenbrachvogel

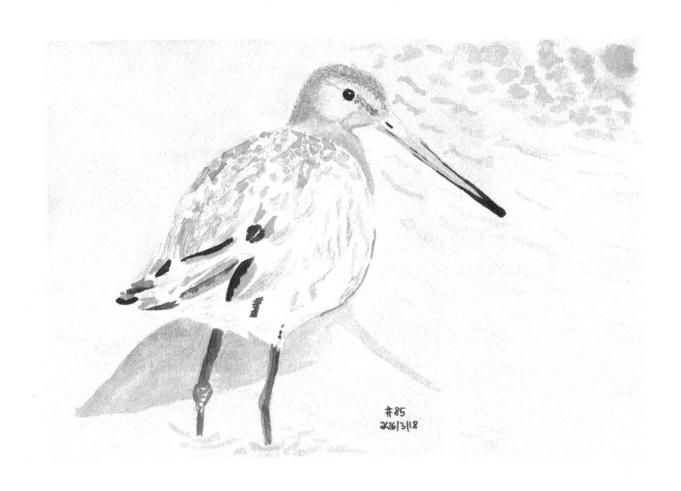

Limosa limosa

Black-tailed godwit ◆ Guilbneach earrdhubh ◆ Uferschnepfe

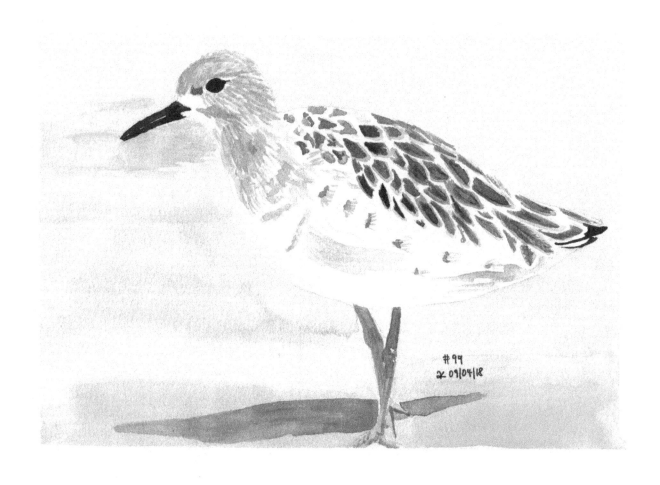

Philomachus pugnax

Ruff ♦ Rufachán ♦ Kampfläufer

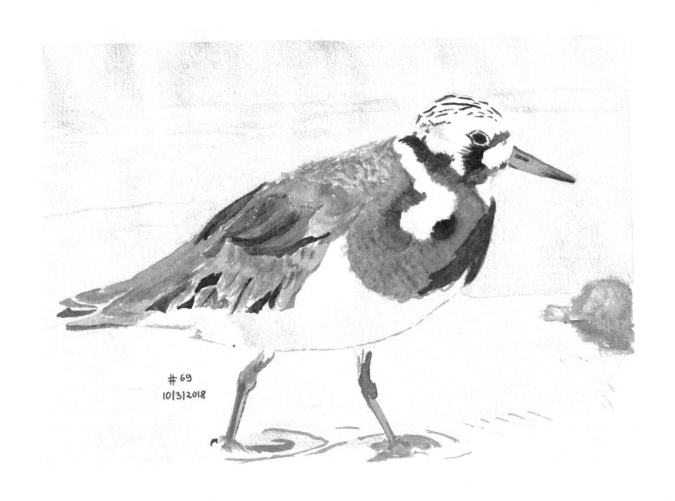

Arenaria interpres

Turnstone ◆ Piardálai trá ◆ Steinwälzer

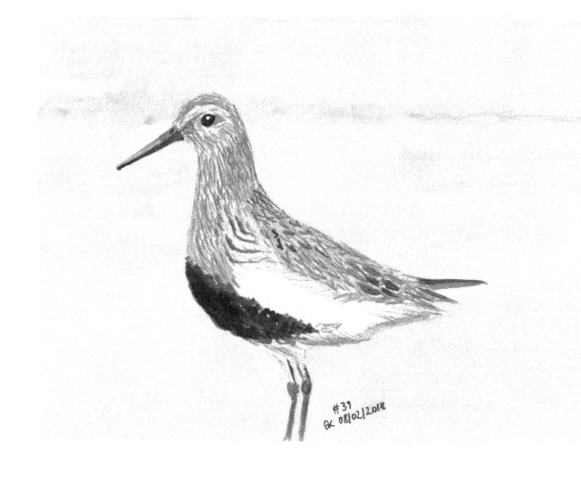

Calidris alpina

Dunlin ◆ Breacóg ◆ Alpenstrandläufer

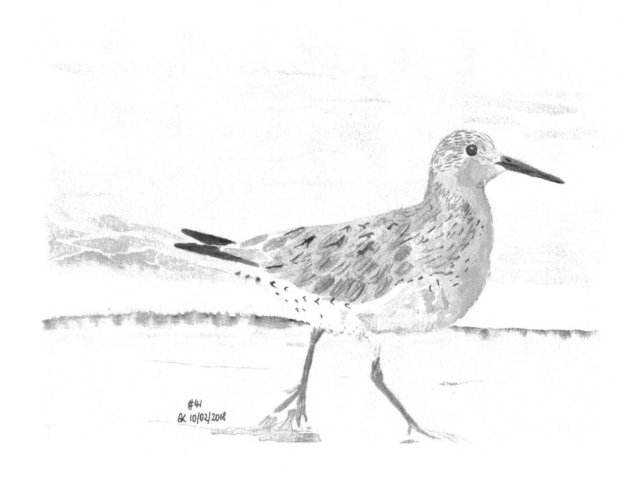

Calidris canutus

Red knot ◆ Cnota ◆ Knutt

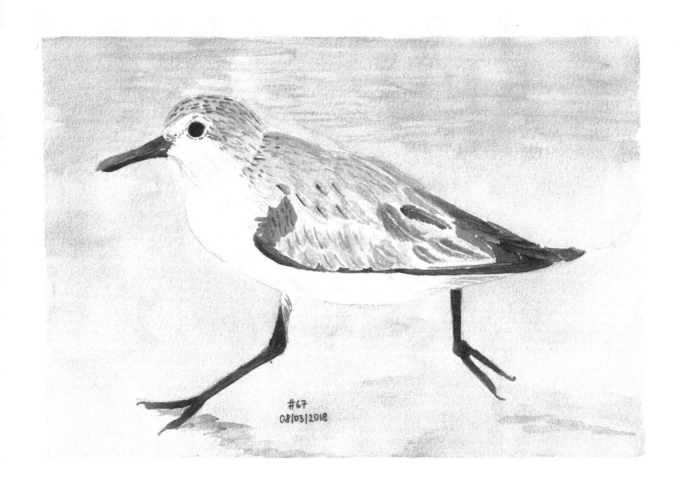

Calidris alba

Sanderling ◆ Luathrán ◆ Sanderling

Printed in July 2019
by Rotomail Italia S.p.A., Vignate (MI) - Italy